CREATIVE
AIRBRUSHING
GRAHAM DUCKETT

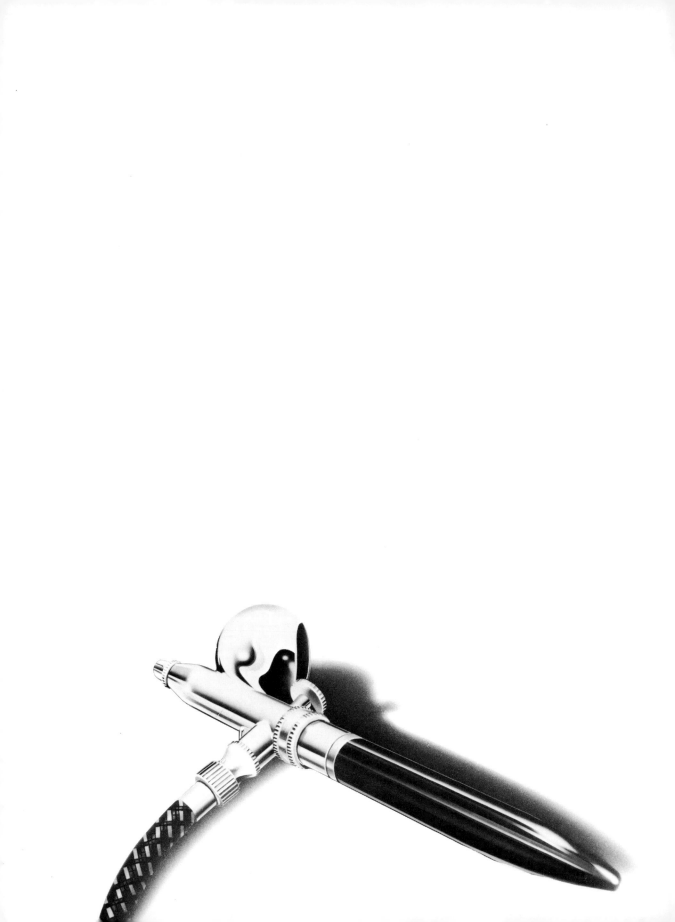

CREATIVE AIRBRUSHING

GRAHAM DUCKETT

COLLIER BOOKS
MACMILLAN PUBLISHING COMPANY
NEW YORK

Macmillan Publishing Company
866 Third Avenue, New York, N.Y. 10022
Collier Macmillan Canada, Inc.

Library of Congress Catalog Card Number: 85-392
ISBN: 0-02-011260-2

Macmillan books are available at special discounts for bulk
purchases for sales promotions, premiums, fundraising,
or educational use. Special editions or book excerpts can
also be created to specifications. For details, contact:

Special Sales Director
Macmillan Publishing Company
866 Third Avenue
New York, New York 10022

10 9 8 7 6 5

This book was edited, designed and produced by
The Paul Press Ltd

Art Director Stephen McCurdy
Senior Editor Jane Struthers
Designer Tony Paine
Art Assistant Jacek Depczyk
Line Illustrations Hayward and Martin Ltd
Project Photography Andrew Stewart
Additional photography Bruton Photography Ltd

Editorial Director Jeremy Harwood
Publishing Director Nigel Perryman

Typeset by Wordsmiths Ltd, Street, Somerset
Origination by Rainbow Reproductions Ltd, London

Printed in Singapore

Contents

Foreword

Before I started studying at Blackpool Technical College in 1968, airbrush art filled me with a mixture of trepidation and admiration. In the past I had often wondered how illustrators achieved that beautifully smooth, and almost photographic, quality in the work I saw published. Being told that it was all done with an airbrush didn't satisfy me, only making me keener to discover more about the process and at some time be able to practice it myself. I have now been working as a professional airbrush illustrator and lecturer for over twelve years, and the airbrush remains my first love for illustration.

This book is purpose-planned for the reader who is interested in airbrushing but has had little or no experience in the art. What makes it especially valuable, I feel, is the series of projects, each one designed not only to enable you to practice and become proficient with each process before moving on to the next one, but to create your own finished work right from the start, instead of working through a whole list of exercises in isolation. This means that you can learn at your own pace, taking time to familiarize yourself with the airbrush. At the end of the book is a collection of illustrations by professional artists to show the wide variety of effects that can be achieved with the airbrush. When you first begin using an airbrush, there is no point in spending a large sum of money on a model that is too sophisticated for you. There are many good, inexpensive, airbrushes available, all of which are ideal while you are still learning. Once you have mastered the basic techniques, and decided how much time and money you want to spend, you can then consider buying a more expensive instrument. Another point to bear in mind is that some airbrushes are manufactured for a specific purpose, such as model-making. You should therefore know the way in which you want to use your new airbrush before you buy it. You can then choose one that has been specifically designed for the purpose you have in mind.

When you buy your first airbrush you must also buy a supply of compressed air at the same time, since airbrushes do not work independently – they need an air supply to propel the medium through the brush and on to the board or paper. The best choice for the beginner is the simple and cheap canister of compressed air, which is available from art shops. Wait until you are sure you want to invest both your time and money in airbrushing before you buy a more expensive supply of air, such as a mini-compressor.

Mastering the airbrush takes time and patience, but once you have succeeded – with the help of this book – you will find that an airbrush introduces you to many new techniques. Its extreme versatility means that it is suitable for much more than just illustrations – the airbrush is also used in such diverse activities as model-making, glazing ceramics, car-customizing, interior design and even cake decoration! Remember that the airbrush shouldn't dictate to the artist – it is the artist who dictates to the airbrush, using it to produce whatever effect he or she requires, whether for an illustration or a mural on a wall. I hope that this book will introduce you to the airbrush, and help you to discover for yourself the enormous scope it offers.

Graham Duckett
London 1985

Understanding the airbrush

The airbrush is a piece of precision equipment so, to get the best out of it, you must understand how it works. However, an airbrush alone is not enough to create an illustration; you need an air supply to propel the medium, as well as drawing equipment to plan the illustration and masking equipment to contain the flow of the medium within specific areas. This section also shows you how to maintain your airbrush, to keep it at the peak of its performance.

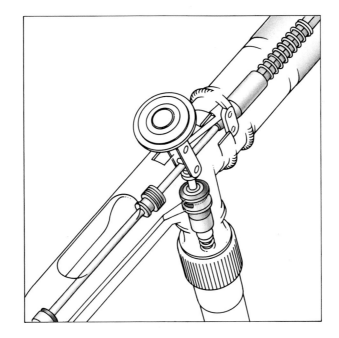

The airbrush/1

Invented by Charles Burdick, a watercolour artist, in 1893, the airbrush has become an indispensable tool for today's graphics industry. It is a measure of the quality and completeness of his design that today's airbrushes retain most of the features of the original nineteenth-century model.

Basically, the airbrush works on the principle of internal atomization. Compressed air is allowed to flow through a nozzle supplying the paint. A partial vacuum at the front of the nozzle orifice causes the paint to flow. The paint then mixes with the compressed air and atomizes into tiny droplets to form a spray. The spray can be controlled and its characteristics altered by regulating the ratio of air and paint, using a control lever. It is this control, and the degree to which it can be achieved, that characterize the different types of airbrush on the market – single-action, double-action and independent double-action – and determine which type of airbrush you will buy.

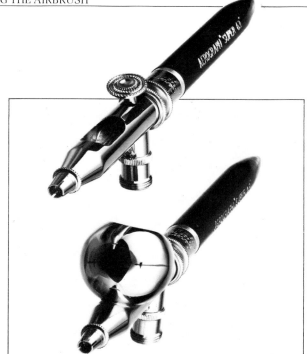

De Vilbiss Super 63
These are independent double-action airbrushes of professional standard. Model *A (left) produces a very fine line, while Model E (right) gives a slightly thicker line and has a larger reservoir.*

How the airbrush works

The air cap at the front of the airbrush houses the nozzle and centralizes it to allow an even flow of air to pass around it. Attached to the air cap by a screw thread is the nozzle guard, which protects the nozzle from damage. Nozzle guards usually have slots or small holes cut into the sides to prevent 'blow-back' of the paint when working very close to the ground – the name given to the board or paper on which you will spray.

The nozzle is the most important part of the airbrush, because it is responsible for the final paint spray. It is machined to very fine tolerances, and is tube-shaped, tapering towards the front of the airbrush, with a final diameter of 0.012in (0.30mm). The tapered fluid needle moves backwards and forwards inside the nozzle, and the combined effect of the tapering nozzle and fluid needle regulates the flow of liquid from the medium reservoir. (It is important that the finely-ground point of the fluid needle is maintained, otherwise the performance of the airbrush will be impaired.) The needle passes through the needle spring box between the prongs of the fork of the control lever and continues until it gently seats in the nozzle. It is then fixed in position by the needle locking nut.

The air supply is controlled by the air valve assembly which is housed in the neck. This consists of a diaphragm attached to a spring-loaded tapered valve stem that acts against the valve washer. The control lever works on the diaphragm, which in turn opens the valve to release the air. This lever is attached to the body by a retaining screw, and not only releases the air when downward pressure is applied but, when it it pulled backwards, draws the needle out from the nozzle to allow the paint to flow. An adjustable cam

arrangement is incorporated into the body of the airbrush. It can be locked to fix the position of the needle and thereby allow a uniform amount of paint to flow when the air valve is operated. This arrangement is used when performing repeated colouring operations. A handle covers the needle spring box assembly and also balances the airbrush.

Single-action

This airbrush has only one control point – the air valve. When the push-button control is operated the airflow draws out the paint, producing a spray. Because the only control is the air valve, it is not possible to alter the ratio of paint to air. Therefore, the only way of altering the texture and character of the spray is by varying the distance between the airbrush and the ground. This means the single-action airbrush can only be used to apply flat tones and soft vignettes for backgrounds and model-making.

Double-action

These airbrushes have the added feature of a variable paint flow. The control lever operates both the air and paint, so that when the lever is drawn back the airflow and the flow of paint increase. However, the ratio of air and paint cannot be varied.

The only advantage of the double-action airbrush over the single-action type is that the quality of the spray is more even, more consistent and more

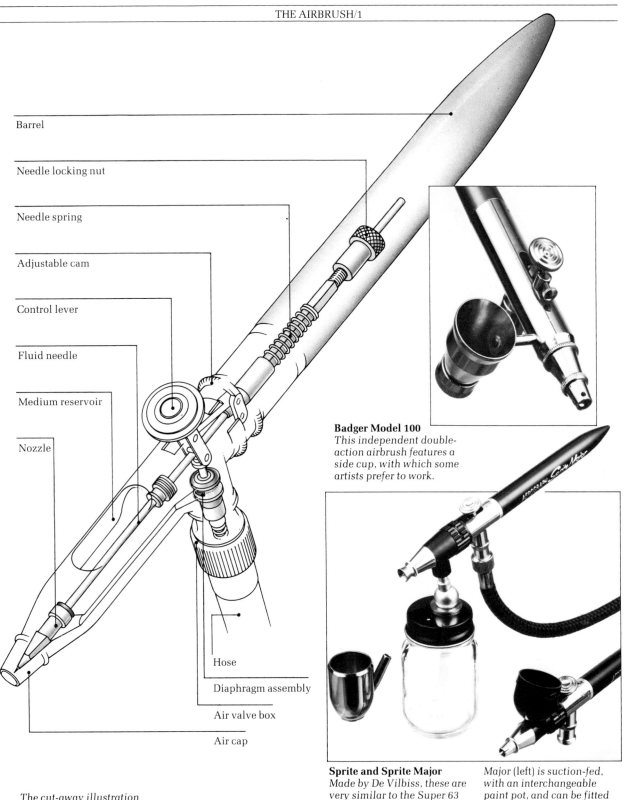

Barrel

Needle locking nut

Needle spring

Adjustable cam

Control lever

Fluid needle

Medium reservoir

Nozzle

Hose

Diaphragm assembly

Air valve box

Air cap

The cut-away illustration shows an independent double-action airbrush.

Badger Model 100
This independent double-action airbrush features a side cup, with which some artists prefer to work.

Sprite and Sprite Major
Made by De Vilbiss, these are very similar to the Super 63 series. The Sprite (right) is gravity-fed, while the Sprite *Major (left) is suction-fed, with an interchangeable paint pot, and can be fitted with a high flow nozzle to spray large areas.*

The airbrush/2

controllable. It is a reasonable choice for the beginner but it does have limitations for the creative artist.

Independent double-action

These are the most popular type of airbrushes and are preferred on the whole by professionals. With this type of airbrush, the air/paint ratio is variable and is controlled by pressure on the finger lever. A downward pressure controls the air supply and a backward movement releases the paint. This allows the artist to spray a line as thin as that produced by a pencil, and then continue to a broad tone in a single sweep of the airbrush. This is the type of airbrush used in the following projects (see pp34-89), and it is recommended to those who wish to develop their technique to the full.

The paint supply

There are two methods of supplying the airbrush with the medium – by suction and by gravity. In the suction method, in which the paint reservoir sits underneath or to the side of the body of the airbrush, the paint is drawn up by the vacuum created by the flow of air past the nozzle. Gravity feed, as its name suggests, has the reservoir above the body of the airbrush.

The advantage of certain suction types, in which the paint is contained in screw-on jars, is that changes of colour can easily be made by simply unscrewing one jar and replacing it with another. However, the position of the jar means that you cannot hold the airbrush very

De Vilbiss Imp
At the opposite end of the range from the expensive professional airbrushes is this very simple model, which is a basic, single-action, spray gun. The airflow can be adjusted by turning the knurled knob at the end of the handle. The Imp is best used for model-making and when spraying large areas.

close to the board, as is necessary for close, detailed work. Gravity-fed models have the paint reservoirs fixed to the body. This makes them ideal for close work, but means that changing colours requires first emptying the reservoirs, cleaning them and then refilling them with another colour.

Propellant systems

An airbrush must have a supply of compressed air to propel the paint. There are many different propellant systems on the market, ranging from small cans of compressed air to electrically-driven compressors on which the air pressure can be regulated. These vary in size and capacity from the portable mini-compressor, to the large piston-type models.

Air canisters

These provide an immediate supply of air and are likely to be the first choice for the beginner, because they are inexpensive and easily available from art shops.

The only accessories required with an air canister are a control valve and a flexible hose. If possible, choose a control valve which can vary the air pressure. The majority of valves release an unvarying amount of air pressure, and although this is suitable for most applications, in some circumstances it is necessary to increase or reduce the pressure to the airbrush.

However, air canisters do have some disadvantages. Firstly, the pressure, which regulates the spray, tends to drop gradually as the canister empties. Secondly, since the canister contains a limited amount of air, it will eventually empty completely, usually at an inconvenient time. For this reason you will find it helpful always to have a spare canister available. Thirdly, it can become extremely expensive to use air canisters continually – the money spent on twenty canisters will buy a small compressor. Therefore, you might find that investing in a small electric compressor may be well worth the initial outlay.

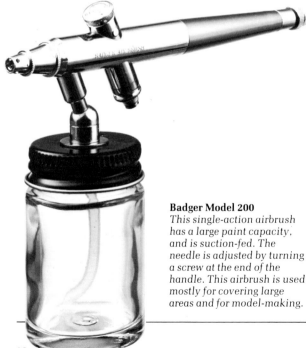

Badger Model 200
This single-action airbrush has a large paint capacity, and is suction-fed. The needle is adjusted by turning a screw at the end of the handle. This airbrush is used mostly for covering large areas and for model-making.

Compressors

Anyone who intends to do a great deal of work with an airbrush should seriously consider buying a compressor. An electric motor keeps the air at a constant pressure and also extracts the moisture content, to prevent it building up and flooding the airbrush. The compressed air then flows into the airbrush through a hose.

A range of compressors are available, of which the most basic are mini-compressors which consist of an electric motor driving a tiny piston or diaphragm. They are relatively inexpensive, costing the same as a middle-range airbrush, and are an ideal choice for the airbrush enthusiast.

Mini-air compressors, however, have drawbacks. Firstly, because the air comes directly from the compressor, there is a tendency for it to flow in a series of pulses. These will affect the paint flow, giving an uneven finish. Secondly, moisture traps, or water filters, are not normally fitted to mini-compressors. At best this can be a nuisance, at worst disastrous if water spits on to the painted area and ruins the surface.

The larger units incorporate a reservoir, which stores air at a constant pressure. They are either diaphragm- or piston-type compressors. Each has particular advantages. The diaphragm compressor is oil-free and so need not have an oil filter attached. The piston type, on the other hand, is a generally sturdier unit, and can be used to generate a higher pressure. Some piston-type compressors incorporate an air reservoir, a pressure cut-out switch, regulating valve, oil and water filters, and they can feed a constant supply of air to as many as twenty airbrushes at any one time. All of these larger compressors usually feature a pressure cut-out switch, a pressure regulating valve, filters for oil and water removal and multiple outlets.

With a little ingenuity you can build a perfectly adequate compressor yourself using everyday items. For instance, an old inner tube from a car tyre will act as an air reservoir and it can be refilled easily using a foot pump. You will have to buy, or make, an adaptor to make the valve accept the air hose but little else is needed and you will have a cheap (if somewhat exhausting) air supply.

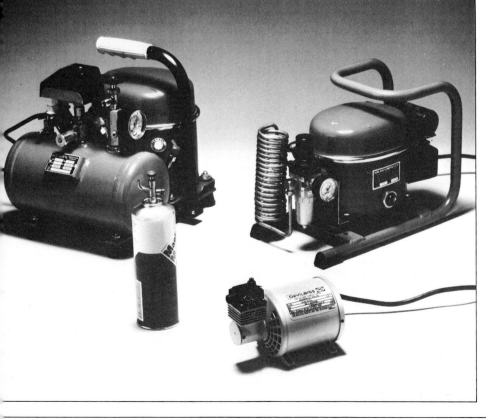

Air supplies

It is important to choose the right sort of air supply for your needs. If you do not intend to use your airbrush much, you might find it best to buy a simple aerosol propellant (bottom far left). However, you may feel that buying a mini-compressor (bottom left) would be a better investment. This model is mains-operated and has an oil-free piston. It can be used with most makes of airbrush. The large compressor (top far left) has outlets for five airbrushes, which can be used simultaneously. This makes it ideal for studio work. It is a compact motor piston compressor, with a relay switch, thermal cut-out, automatic pressure switch and a moisture trap. The smaller compressor (top left) is suitable for both professional and amateur airbrush artists, and can supply air to two airbrushes at the same time. This model has a filter and moisture trap and a thermal cut-out.

Equipment/1

Although you will be working principally with an airbrush, you will need several pieces of drawing equipment in order to produce an initial outline from which to work.

Pencils

There are 17 grades of drawing pencil from which to choose, ranging from 6B, which is the softest, to 9H, which is the hardest. However, you are only likely to need the soft B pencils for sketching. For more technical drawing and work on tracing paper, when the accuracy of line is vital, the harder, H grades, of pencil should be used.

Coloured pencils of standard weight are useful for planning a design, and some artists use them to put the finishing touches to illustrations instead of using a brush. Sets of coloured pencils are widely available in ranges of up to seventy different colours.

Erasers

Like pencils, erasers range in texture from soft to hard, and you will find it necessary to have at least three kinds. A kneaded, or putty, rubber is useful for removing marks from areas of a drawing before you begin spraying. A pencil rubber is normally quite soft and will not mark paper. However, it can affect the surface of the board or paper, and alter the finished texture of the paint, and so it should be used carefully and sparingly. A stick rubber is useful for removing mistakes in detailed work and is sometimes used to create highlights by gently rubbing away areas of sprayed paint. However, if you use a stick rubber for highlighting, make sure that you have finished using the airbrush and that no further spraying is required. The stick rubber removes the surface of the line board, and any overspraying of the area on which it has been used will be noticeable.

Dividers and compasses

Although it might be tempting, it is not necessary to buy one of the impressive and expensive sets of drawing instruments you may have seen in your local art shop. You will have no need for many of the objects you are buying, and they will simply be a waste of money.

However, you will need a modest set of drawing instruments. This should include a pair of dividers for scaling up a grid, and a compass, preferably with an extension arm, for drawing circles. If you intend to make enlargements or reductions from original reference material you will also need a pair of proportional dividers. These are quite expensive to buy but are worth the initial outlay. As well as enlarging and reducing, they can be used to divide lines and circles into any number of equal parts.

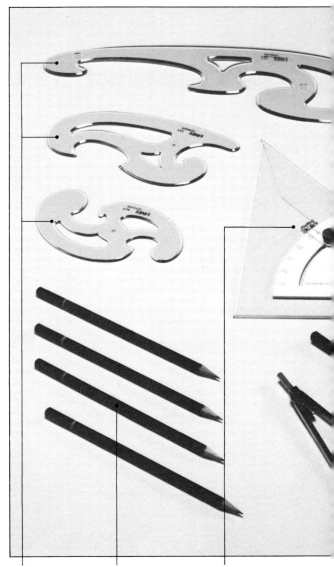

French curves
These are available in a variety of sizes, and have a number of deep and shallow curves around which you can draw.

Pencils
You will need several grades of pencil. Choose a soft one, such as a 2B, for shading in and a hard one, such as a 4H, for tracing over outlines, as well as an HB and an H.

Adjustable set square
This is the most useful of the set squares, since you can adjust it to form any angle.

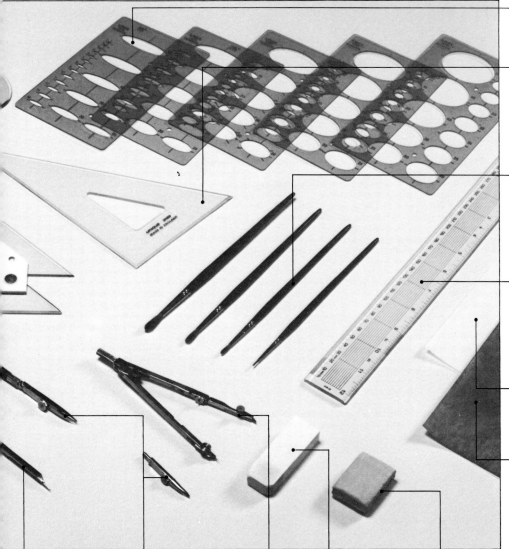

Ellipse guides
These are available in many different sizes and angles.

Set square
This set square has three fixed angles. You can use it against a steel rule and also use it to check the accuracy of existing angles.

Paintbrushes
You will need sable paintbrushes in a variety of thicknesses, ranging from very thin ones for lining in to thick ones for loading airbrushes with paint.

Ruler
A ruler is indispensible to an airbrush artist. One made of plastic is especially useful as you can see outlines through it.

Tracing paper
You can use tracing paper for working out and scaling up illustrations.

Tracing down paper
This is made specifically for transferring the outline of an illustration to the line board.

Dividers
A pair of dividers is invaluable when scaling up drawings and marking off equal divisions.

Ruling pen
Once this is filled with paint you can use it to draw fine lines.

Ruling pen attachment
This can be filled with paint and then fitted to a compass, to allow you to describe circles in paint.

Compass
You will need a compass, fitted with a pencil, for drawing accurate circles.

Pencil rubber
This soft rubber will erase pencil lines but may mark the surface of a line board.

Putty rubber
This rubber should be used on line board, because it is non-abrasive and therefore will not damage the surface.

Equipment/2

French curves

These are drawing instruments, made of rigid transparent plastic, specifically designed for drawing curves of a variety of shapes and sizes. French curves are available in different sizes, and can be bought in sets of three or four, or individually.

Ellipse guides

Ellipse templates, specifically for drawing ellipses, are an indispensable time-saver for technical drawing, since you can draw around them instead of having to construct your own ellipses. The guides are sold both in sets and individually, in sizes ranging from $\frac{1}{8}$in (3mm) to 'jumbo' sizes of 8in (20cm) or more. You can also buy ellipses of varying angles, from 10° to 80°

Grounds

The choice of subject will determine the type of ground – the surface on which you will work – that you need. Each type has a different 'tooth' – the more tooth a ground has, the deeper the texture of its surface. For precise technical work for reproduction, grounds with a fine tooth are the ideal choice. You should use watercolour paper for less detailed airbrushing, or work that requires a textured surface. However, the difficulty with such paper is that, when masking film is used, paint will inevitably creep underneath the masks because of the texture of the surface, giving a less than sharp result. Also, when removing masking film, the surface of the paper may also be lifted off if you are not very careful.

Line boards have smooth finishes and are available in a variety of sizes. There are many different makes on the market, some of which are sold in paper form, and are less expensive than actual boards.

Modern photographic papers are ideal grounds for airbrushing, as they have smooth, stable surfaces. They also have an additional advantage, since it is simple to wipe off paint once it has been sprayed on to their non-absorbent surfaces. The extreme white of the photographic papers makes them ideal for work with watercolours and inks, as their vivid colours are enhanced by the reflectivity of the surfaces.

Tracing down paper

In order to transfer a finished line drawing to the ground, you will need to use a sheet of tracing down paper positioned between the original drawing and the ground. You can either make tracing down paper yourself or buy sheets or rolls of specially-developed transfer sheets in different colours to suit your needs.

Tracing down paper is not the same as carbon paper, and gives an outline which can easily be lifted from the ground with a soft rubber. To make your own tracing down paper, take a sheet of thin tissue paper, approximately 10 x 12in (25 x 30cm) and spread an even layer of jewellers' rouge (available from most art shops or jewellers' shops) over the surface with a wad of cotton wool. To transfer the fine line required from the drawing on to the ground, you trace over the outline using a hard pencil (such as a 9H), or a steel point with a blunt end. You can also trace the outline on to a sheet of tracing paper, rub over the back of it with a soft pencil, then treat it as you would tracing down paper.

Fixative

When you have finished an airbrush illustration you will need to 'fix' it – literally fix the paint to the surface of the ground. Gum arabic is the ideal fixative, as it is water-soluble, and can be diluted to be sprayed through the airbrush on to the illustration. There are other aerosol-type fixatives, but none have the control that gum arabic, sprayed through the airbrush, will give you. Fixing an illustration not only seals the paint but adds a translucency, bringing out a new depth in the colour. As always, when you have finished spraying with gum arabic, you should thoroughly flush out the airbrush until it is clean or it will become clogged.

Rulers

Rulers are used for measuring, lining in, as straight edges when cutting, and for guiding the airbrush when spraying fine straight lines. You will find it very useful to have more than one type.

A steel ruler is useful as a cutting guide – don't use plastic or wooden rulers, as you may cut into them and into your fingers at the same time. A transparent plastic ruler, with metric and imperial markings, is ideal for measuring and drawing. A ruler of approximately 24in (60cm) is ideal for projecting lines to vanishing points when drawing in perspective.

Set squares

These are available in three types – 45°, 60°/30° and those with adjustable angles. It is best to have one of each type, but if you are working to a budget, you will find that an adjustable set square is the most versatile. The non-adjustable set squares are available in large sizes, up to 24in (60cm); these are very useful for working on large drawings.

Ruling pens

A ruling pen is an instrument specifically designed for drawing ruled lines of varying widths. It consists of two blades, both of which lead to a point. Paint or ink is inserted between the two blades and flows out at the point. The width of the point can be adjusted by a screw. Compasses for drawing circles are also available.

Ruling pens can be used with any free-flowing medium, applied by brush or glass dropper.

Drawing boards

It is not necessary for an airbrush artist to have an elaborate, expensive, drawing board. What is required is a solid smooth board with a slight incline – one of 10° is comfortable. The size of the drawings on which you intend to work will dictate the size of board you require, but it is unlikely that you will need one larger than A1 (840 x 594mm). There are quite inexpensive boards on the market, which incorporate a parallel motion mechanism and can be adjusted to various angles. Drawing boards are compact enough to fit on a table and, when not in use, can be stored in a cupboard. If a simple drawing board is used, choose one made from slats with battens behind them to act as strengtheners. If the board does not have a parallel motion mechanism, you will need to use a T-square when drawing parallel lines.

General studio equipment

In addition to the items already mentioned, there are other, more general, pieces of studio equipment that you will need. Knives are among the most important pieces of equipment; several types of studio knives are available from most art shops.

For light cutting jobs, the medical scalpel, which is cheap and easily available, is most widely used. Not only is it well-balanced but it is available with differently-shaped handles and easily-changeable blades, which make it the best choice for the airbrush artist. You can also buy scalpels with rotating heads for cutting curved lines, but they blunt very easily. Scalpels are too lightweight for cutting heavy card and board, so use a sturdy craft knife run along a steel cutting edge instead.

You will need containers in which to mix paints. White ceramic palettes are widely available and very useful. They are sold in a variety of shapes – some are flat and some are specially made so that they can be stacked. The advantage of the latter is that you can keep mixed paint in one palette, and stack another palette over it to prevent the paint drying up in between work periods. (It is difficult to re-mix a shade to match the original.) However, palettes can be easily improvised from old saucers.

Paintbrushes

These are very important pieces of equipment and must be chosen carefully. You should always buy the best possible brushes you can afford if you are to achieve the high standard required when finishing illustrations. The best brushes are made of sable and have a seamless ferrule. The brush heads are round and must taper to a fine point when wet.

Don't be afraid to be selective when buying such important and relatively expensive items as the brushes that you will use for finishing and lining in – they can make or ruin an illustration. It is quite normal to ask the shop assistant for a jar of water with which to test the point of a brush. Always ask to be given a selection of brushes and then choose the best.

Choosing the medium

Once you have bought these additional pieces of equipment, there is still one very important item you have to choose – the medium, ranging from gouache to watercolours, inks, acrylics and oils.

The important point to remember is that the medium has to be thin enough to pass through the airbrush needle without clogging it, and has to be soluble, with no solid particles that might block the nozzle and thus spoil an illustration. For this reason, poster colours are unsuitable for use with an airbrush because they are not completely soluble, and leave a deposit of solid particles at the bottom of the reservoir.

Gouache

This opaque, water-soluble paint (sometimes referred to as designer's gouache) is widely used by airbrush artists. It is available in tubes and jars in a range of up to seventy different colours. Gouache must be diluted with water to the required consistency – usually that of milk – before use. Being finely ground, it is ideal for use with an airbrush, and is easily flushed away with water when you have finished using it.

There are two shades of white gouache available. Zinc white is used for mixing with other colours to produce brighter tints, while permanent white is used for highlighting.

Watercolours

These are more finely ground than gouache and lack its opaque white base. Instead they give transparent colour. Watercolours are available in both tube and tablet form in a wide range of colours which, when diluted with water and sprayed on to a white ground, produce a result that has a luminous quality you cannot achieve with gouache.

Recently, liquid watercolours have been developed specifically for use with the airbrush. These colours, which can be used directly from the jar, are intensely brilliant, transparent, and can be easily mixed. If a more opaque result is required, the watercolour should be mixed with zinc white gouache. Because watercolours tend to bleed, a special opaque white should be used when covering and painting highlights.

Equipment/3

Acrylics

These give very intense, attractive colours, and are available in a range of approximately seventy colours. They are sold in both tubes and pots, and have to be diluted with water before use.

When acrylics dry they are no longer water-soluble and will form a skin in the reservoir of the airbrush which, if allowed to settle in the nozzle, will eventually clog it and affect the performance of the airbrush. Therefore, it is extremely important that you should thoroughly clean the reservoir with water after each application of acrylic paint.

Inks

There are various types of ink on the market. These can be divided into two sorts – waterproof and non-waterproof. Care should be taken when using waterproof inks, as these have a tendency to separate and should not be allowed to dry in the airbrush, as they will form an insoluble deposit. Non-waterproof inks have similar characteristics to watercolours. They are only available in a limited range of colours but they can be mixed to produce many different shades.

Oil paints

If properly thinned with turpentine, oil paints can be used in the airbrush. They are used by artists who want to produce a particular effect, such as a vignette, but because of their slow-drying properties, they are unsuitable for most other applications.

If you do decide to spray with oil paints, you should be extremely careful when using masks. Adhesive masks will not adhere to the wet surface, and laying loose masks could smudge the wet paint. When you have finished spraying, you should immediately thoroughly flush all the remaining oil paint out of the airbrush, first using turpentine and then clean water.

Masking equipment

The very nature of airbrushing – forcing a fine spray of paint through an airbrush – means that the artist does not have the same degree of control as when applying paint with a paintbrush. As a result, the areas which are not to be sprayed have to be masked off, to prevent the paint touching them. Any material which prevents the airbrush spray from reaching the surface of the illustration is effectively a mask. Normally, however, when masking film is mentioned – both in this book and generally – it refers to a type specially developed to be used with an airbrush. This masking film is transparent, with a low-tack adhesive protected by a backing sheet, which is peeled away before use.

When choosing any sort of adhesive masking film, there are certain features to which you should pay

Masking film
This is sold in rolls of varying widths. The protective backing sheet is peeled away before use.

Liquid masking
Applied with a paintbrush, this can be used to mask small and complex areas.

Masking tape
Masking tape has a low-tack adhesive, which means it can be stuck on a ground, sprayed against, and removed without harming the surface.

Blotting paper
The composition of blotting paper means it gives a soft edge when sprayed against.

Tracing paper
When this is used as a mask it gives a precise sharp edge.

Ruler
This makes an effective loose mask when sprayed against.

Cartridge paper
Spraying against a torn piece of cartridge paper will give an interesting outline.

particular attention. The first is transparency, since it is very important that your original line drawing, from which you will be working, can be seen clearly through the masking film when it is laid over it.

The second important feature is the tackiness of the film, because masks are often used several times during one project. Obviously, when laying film over previously sprayed areas of a drawing, the last thing the artist wants is for the underlying paint to be pulled off when the masking film is removed. To prevent this happening, you should choose a film which can be lifted and replaced repeatedly without affecting the surface of the paint. Finally, it is important that the

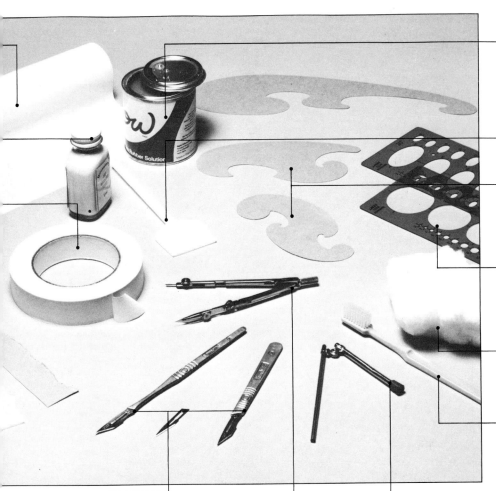

Cow gum
Although this is more commonly used as an adhesive, you can use it to mask areas of an illustration and then rub it off after spraying.

Cow gum applicator
This is a spatula with which you can apply the cow gum.

French curves
If you want a curved shape, you can spray against a paper template of a French curve, moving it around to find the desired shape.

Ellipse guides
You can choose the size and angle of ellipse you want and then spray through the appropriate shape in an ellipse guide.

Cotton wool
Many substances can be used as masks, including cotton wool, which gives a diffused, cloud-like, effect.

Toothbrush
An old toothbrush is ideal for creating a spatter effect. It is dabbed in some paint and then a stiff object is drawn over the bristles to make the paint spatter over the ground.

Surgical scalpels
These are available with various sizes of handle. You can also buy differently-shaped blades that are interchangeable.

Compass with scalpel
A scalpel blade can be fitted between the blades of a ruling pen attachment for a compass. This enables you to accurately cut circular masks from film or paper.

Atomizer
One end of this is placed in paint and the other end in the artist's mouth. Blowing down it will produce a fine spray of paint.

mask retains its shape after the repeated lifting and laying procedures which take place during a project. The masking film you buy should not be so soft that it is soon pulled out of shape.

Liquid masking
Not all masking is made up from sheets. Liquid masking is a rubber solution thin enough to be applied with a paintbrush. It evaporates quickly to leave a dry flexible skin which acts as an effective mask. This is particularly useful when masking small intricate shapes which would be difficult to cut from a sheet of masking film. Unlike masking film, which can be

re-used, liquid masking can only be used once. After use, the dried film can be easily rubbed off with a finger. Alternatively you can remove it by rubbing it away with a ball of the dried solution.

Loose masks
Loose masks differ from masking film and liquid masks in that they are non-adhesive and can be moved around by hand during spraying to create a softer or graduated outline. A number of materials can be used to make loose masks, which are cut or torn to the required shapes; these include paper, stiff card, photographic film, templates and metal rules.

Maintaining the airbrush

Avoiding vital basic maintenance checks means that your airbrush may well end up as an expensive, useless toy. It is important that the brush is cleaned thoroughly after each and every job, as otherwise the paint channels will become clogged and the brush simply will not function properly. You should also flush your brush through with clean water after each application of colour and, in the case of oil- and spirit-based media, with the appropriate solvent.

As well as keeping the paint channel clean and paint-free, you should check the airbrush needle in the nozzle regularly to see that it is clean and straight. If it is bent – the characteristic sign of this is a spattered, uneven spray – replace the needle with a new one. Never poke anything into the nozzle in an attempt to clear it, as this is a sure way of damaging the needle beyond repair.

The cam mechanism will need to be serviced occasionally, but as this is a somewhat delicate component of the airbrush, it is best to ask an expert to service it for you at regular intervals. You may also find that media erode the nozzles of airbrushes, and they will have to be replaced.

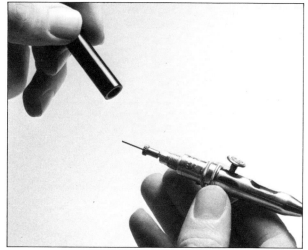

1 Checking and cleaning the airbrush needle
Turn off the air supply and disconnect the supply hose. Remove the rear cap to expose the needle locking nut.

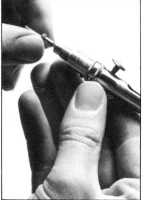

2 Releasing the needle
Unscrew the locking nut two turns. Do not use excessive pressure and make sure that the lever control button is pressed forward and down.

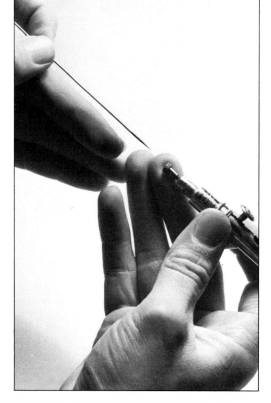

3 Checking the needle
Gently remove the needle. Check it for dirt and to see whether or not it is bent. If it is bent, there is no point in trying to straighten it. You must fit a new needle. ▷

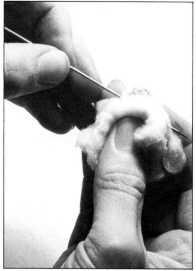

4 Cleaning the needle
Wipe the needle with damp cotton wool, working away from the tip. Alternatively, dip the tip in clean water and roll it gently backwards and forwards on tissue paper.

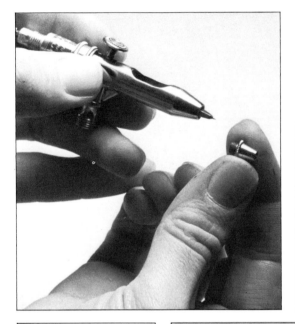

5 Checking the nozzle
Unscrew the airbrush nozzle and check that it is not clogged with paint. If it is, clean it with a wet paintbrush. Never use anything sharp to clean the nozzle as this may damage it. ◁

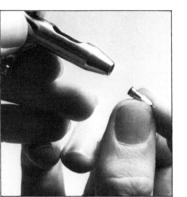

6 Removing the inner nozzle
Remove the inner nozzle and the rubber washer behind it. This washer is extremely small, so be careful not to lose it. ◁

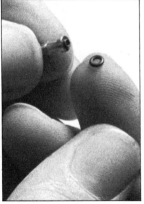

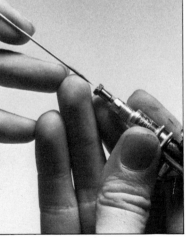

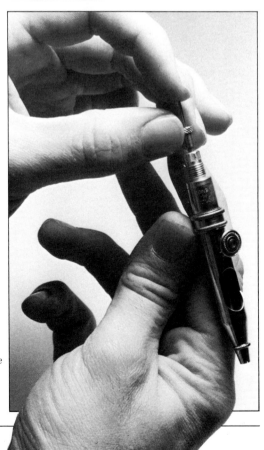

7 Unblocking the inner nozzle
Hold the inner nozzle to your mouth and blow through it. If the washer is worn, fit a new one. Replace the washer and inner nozzle. Screw on the outer nozzle.

8 Fitting a new needle or replacing an old one
Do this very carefully. Slide the needle home with a slight downward pressure until it snuggles against the nozzle.

9 Replacing the airbrush parts
Tighten up the locking nut, but take care not to over-tighten it. Check that the needle moves backwards and forwards freely when the lever control button is operated. Replace the cap. ▷

Using the airbrush

No matter how skilled your spraying, if you cannot master the basic principles of good draughtsmanship, any illustration you work on will be ruined. Equally, if you can draw well but have problems perfecting your airbrushing technique, your illustrations will still be marred. Beginning with very simple exercises, this section shows you how to develop your drawing and spraying techniques to enable you to understand the rules of perspective and reproduce the basic forms of a cube, sphere, cylinder and bowl, from which many objects are composed.

Drawing techniques

An integral part of any airbrush illustration is the careful planning and preparation of accurate line drawings prior to spraying. Whether you intend to produce simple graphic designs, or plan to progress to more adventurous illustrations, you will need to know how drawings are basically constructed.

The simple guidelines given here will help you to construct the fundamental shapes. They will also help you to progress to more complicated drawings by showing you how to develop new shapes from basic outlines you have already drawn.

Using the trammel method to draw an ellipse

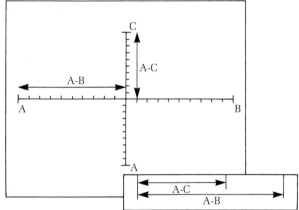

Determine the major and minor axes, and mark them off (above). Mark the dimensions of the major axis, A-B, on a strip of paper, then swing it round and mark the minor axis, A-C, from the same point. By aligning C on the major axis and B on the minor axis, point A will describe a point on the arc of an ellipse. Move the paper around gradually (below), always remembering to align the marks B and C with the axes and marking off the arc of the ellipse at point A. When you have worked around each section, carefully join up the marks with a pencil to describe the complete ellipse.

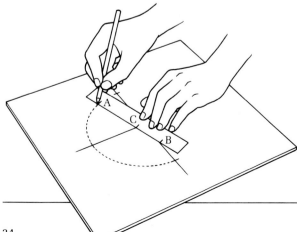

Using an ellipse to construct a square in perspective and in proportion ▷
Construct an ellipse using the trammel method and bisect it at the angle you require. Draw parallel lines at tangents to the points at which the bisecting line cuts the ellipse. Then draw parallel lines to complete the square in perspective. Just as all bisecting lines of a circle are the same length, so all bisecting lines of an ellipse – a circle in perspective – are the same length. Dividing the two intersecting lines into an equal number of parts will produce accurate scales in two planes.

Determining the scale in the vertical plane ▷
Draw a line, F-G, at right angles to the line D-E. (This line will form the major axis of the ellipse.) Take a strip of paper and mark off the major axis, which will be the same as that of the original ellipse. By spanning this from point A to the minor axis, D-E, and by marking the point of intersection of the major axis, you will determine the minor axis. You can now draw the rest of the ellipse, using the trammel method. Drawing a vertical line through the centre point will give the vertical scale which can be divided into the same number of equal parts as before.

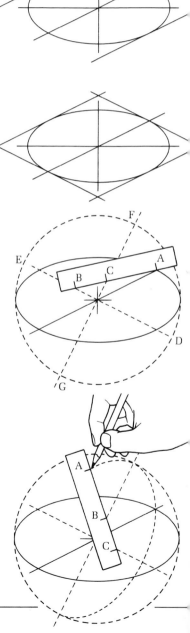

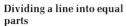

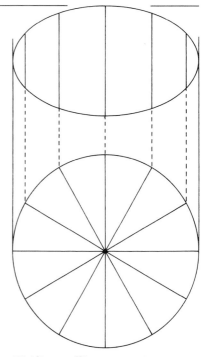

Dividing a line into equal parts

Draw a line, A-B, and determine its length. Working from point A, draw a straight line at an angle to line A-B, then divide it up, using a pair of dividers, into the required number of equal parts. Join point C to point B. Align one edge of a set square with line B-C, and position a ruler along its base. Line up each mark on line A-C in turn and mark off the point where the set square bisects line A-B. This method will divide line A-B into the correct number of equal parts.

Dividing an ellipse

Draw a circle of the same diameter as the major axis of the ellipse, then divide it into the required number of equal parts. Draw vertical lines joining the edges of the ellipse and the circle, then draw lines parallel to these from the points where the circle is intersected.

Enlarging a picture

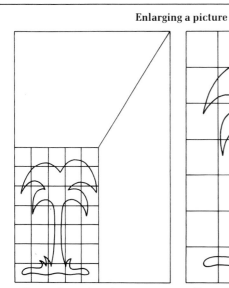

Place a sheet of tracing paper over your drawing or image, then draw a grid of squares over the whole area. Now draw up another grid, on a fresh sheet of tracing paper, to the required size and in proportion to the original. You can enlarge the image by increasing the dimensions of each square – for example, if you want to double the size of the original drawing, draw these squares double in size. Using this enlarged grid as a base, you can then draw in the image square by square on the new grid. You can also use this method to reduce an image.

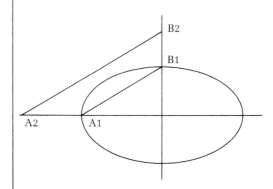

Enlarging an ellipse

Describe an ellipse using the trammel method. Draw a line, A1-B1, from the major axis point to the minor axis point. Now draw another line, A2-B2, parallel to line A1-B1, and ending at the widest and deepest parts of the new ellipse. This will determine the new major and minor axes, from which you can construct an enlarged ellipse.

Understanding the basics

You must be able to control your airbrush if you are to explore fully its qualities and capabilities. You must develop the technical skills needed to manipulate the airbrush to the best effect. This will, of course, require much patient practice, but the following simple progressive exercises will help you to gain confidence in your own ability and give you an understanding of the great variety of effects that can be achieved. Once you are happy with the feel of the airbrush, begin the exercises. Use gouache – a good airbrushing medium – thinned to the correct milky consistency, and use good-quality cartridge paper.

Begin by connecting the airbrush to the hose and compressor, but do not fill the reservoir with any medium. Start familiarizing yourself with the airbrush by practising steady to and fro movements of your arm. Depress the finger lever and draw it backwards as though you were spraying. Practise this until you are comfortable with the feel of the controls. If you find that the hose stops you making smooth movements with the airbrush, you can wrap it around your arm.

To perform the first exercise – spraying a flat, even tone – hold the airbrush perpendicular to the ground and about 5in (12.5cm) away from it, and begin spraying, using smooth sweeping movements of the arm. Before the end of each stroke, ease the lever forward to stop the paint flow, then release the finger pressure to close the air valve. It is important to stop the flow of paint before cutting off the airflow at the end of each stroke, since this prevents the build-up of paint, which would otherwise result at the beginning and end of the stroke. If this happens it will cause blobs.

Next, using the same action, work closer to the ground – about 2in (5cm) from the paper – and spray a broad, even line. If the result is spidery, you have drawn the finger lever too far back, allowing an excessive flow of paint. If, on the other hand, the result is grainy, then either the paint is too thick, or the pressure your finger is applying is inadequate.

When you have mastered broad line, and are able to produce a consistent result, you can progress to fine line. For this, you will need to work as close as possible to the ground – ¼in (6mm) or even closer. This will require very fine control of the finger lever, and the consistency of the gouache and the air pressure will have to be accurately balanced. You can achieve the correct balance only through experience.

Once you have completed the exercises, practise spraying a fine line to a given length, such as 1in (2.5cm). Then spray an arc, following the curve of an ellipse or, for fun, spray your own signature. When you can confidently control your airbrush to this level, you will have learned the basic skills from which to progress and develop your own techniques.

Fine line, hand held
Hold the airbrush about ¼in (6mm) from the ground and spray a fine line, but stop the flow of paint before cutting off the air at the end of each stroke.

Fine line using a rule
Lightly move the ridge of the airbrush nozzle along the inclined edge of the rule as you spray.

Line with raised paper mask
When rendering a straight diffused edge, spray against a loose paper mask held slightly above the ground. Alternatively, spray against an inclined rule.

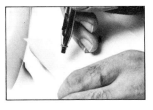

Broad line
Hold the airbrush about 2in (5cm) from the ground and spray soft tones freehand.

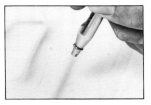

Curved line
Move your hand in a steady and controlled way, using delicate lever action, to soften the edges and render highlights on curved surfaces.

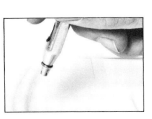

Graduated tones
Spray from the darkest edge and fade off to a lighter tone, holding the airbrush about 3in (7.5cm) from the ground. Graduated tones are used to suggest shadows and convex and concave surfaces.

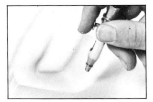

Varying the height of the airbrush
You can vary the height of the airbrush during a single stroke to give an unevenly sprayed surface.

Dots
Working very close to the ground – up to ⅛in (3mm) – spray dots of a consistent density and size. Dots are frequently used for small areas of highlight.

Masking techniques

Once you have completed the simple exercises on the previous pages and can use your airbrush with confidence and skill, you can now begin to practise masking techniques. As I explained in the previous section (see pp16-7), any material which prevents the spray reaching the ground is effectively a mask. The most widely used masking material is a low-tack adhesive film, but many other substances can be used. The exercises on the opposite page show you how to mask using a variety of materials.

Planning masking

When beginning any airbrush work, it is important to plan your masking carefully. Most images can be broken down into basic shapes, colours and tonal areas that can be masked off separately. Although the masking sequence is important, no two artists will choose the same one. It is the artist's ability to analyse the shapes and components of the image that will determine the speed and effectiveness of the style. It is a truism among airbrush artists that a good masking technique can disguise poor airbrushing, but skill in spraying will not hide substandard masking.

Finishing the illustration

Airbrush work is rarely complete without some finishing touches being added by hand, often in the form of highlights. These are applied carefully either with a fine sable brush or a ruling pen.

Masking film

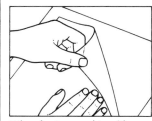

When laying masking film, plan how much of it you will need. Cover the rest of the drawing with detail paper to prevent overspray.

Use a sharp, surgical scalpel to cut the mask. Do not cut around templates but try to cut freehand, taking care not to mark the ground.

After cutting the required shape, hold the scalpel flat and use it to lift a corner of the film without marking the surface of the ground.

Stick the adhesive side of the cut-out mask to the flat of the scalpel blade when repositioning it. This will give you more control.

Lining in

A ruling pen can be used for lining in, because it takes practice to use a brush. You can vary the weight of the line by adjusting the blades of the pen. ▽

You can draw around French curves, ellipse guides or rulers with a ruling pen. Hold the guide slightly above the the ground to avoid flooding. ▽

When finishing a drawing use a steel rule to guide the sable brush. Incline the rule at an angle of 45° and rest the brush against its edge. ▽

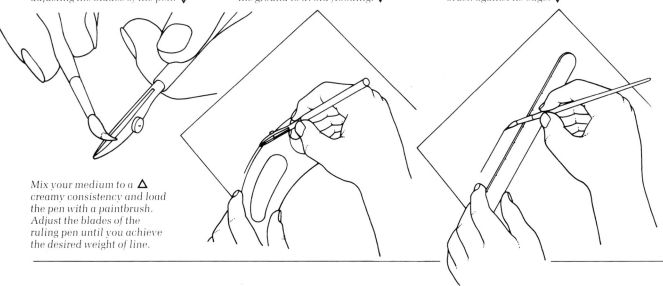

Mix your medium to a △ creamy consistency and load the pen with a paintbrush. Adjust the blades of the ruling pen until you achieve the desired weight of line.

Cartridge paper
Use torn cartridge paper to create an irregular outline, and spray away from the torn edge. You might find it useful to keep the other half of the paper for future use.

Paper raised from surface
Spraying against torn paper held away from the ground will result in a soft, irregular edge. A similar result can be achieved by moving the mask while spraying.

Tracing paper
Torn tracing paper can also be used as a mask, and its brittle texture gives a sharp effect. Because tracing paper distorts when wet, a mask can only be used once.

Blotting paper
A softer, more fibrous, edge can be sprayed using blotting paper. It can only be used once or twice before being discarded because it is porous and unstable.

Overlapping masks
You can create interesting effects by overlapping two or more pieces of torn paper. This can be useful when suggesting the reflections on a polished surface.

Cotton wool
Although it is a somewhat 'hit and miss' method of achieving a soft edge, you can spray against a length of cotton wool to produce a cloud effect.

Spatter
You can create a spatter effect by reducing the air pressure and sharply drawing in the control lever. Alternatively, you can buy a special spatter cap.

Masking fluid
Masking fluid can be used to good effect to produce random-shaped masks. It can also be applied with a fine brush to mask small areas with extreme accuracy.

Fault finding/1

Problems	Diagnosis	Cure
No airflow	Fault in compressor	Check electricity supply and valve/hose connections
	Canister adaptor sticking	Remove from canister, lubricate or replace
	Canister pressure drop	Place can in warm – not hot – water
	Airfeed in airbrush blocked	Remove needle and nozzle, blast air in opposite direction to airfeed while keeping air valve open. Check reservoir for rust and debris
	Lever assembly seized or broken	If seized, try a small amount of light oil. If broken, return to agent for repair
	Air valve stem broken	Return to agent
	Canister empty	Replace
No medium being sprayed	No medium in reservoir	Fill reservoir
	Paint too thick	Empty reservoir and re-mix paint
	Medium dried in nozzle	Remove needle and nozzle and clean
	Medium flow from reservoir blocked	Clean reservoir
	Needle stuck in nozzle	Use thinners to loosen medium. Remove nozzle and needle. Clean and replace
	Pigment settled in reservoir	Add thinner and mix well
	Needle locking nut loose	Tighten
	Lever assembly broken	Return to agent
Bubbles appearing in colour cup	Nozzle cap loose	Tighten
	Nozzle washer badly seated	Remove nozzle and re-seat washer

Problems	Diagnosis	Cure
	Nozzle washer damaged	Remove nozzle and replace washer
	Mismatched nozzle and cap	Replace with matched nozzle seat
Spatter, or spitting	Air pressure too low	Increase pressure
	Solid particles in nozzle	Remove and clean nozzle
	Medium too thick or badly mixed	Add more solvent or re-mix
	Build-up of medium in nozzle cap	Ensure needle is firm and straight. Clean with brush and thinners
	Worn or damaged nozzle	Replace
	Nozzle or needle mismatch	Replace one or both
	Dirt, oil or water in air supply	Remove nozzle and blast air through. Clean or install filters
	Medium allowed into lever aperture, damaging diaphragm	Return to agent
	Nozzle washer worn, allowing medium to seep into air passage	Remove nozzle and blast air through air passage. Renew washer and replace nozzle
Spatter at an angle	Needle bent	Repair, using fine abrasive block, or replace
	Nozzle damaged	Replace
Spatter at beginning of stroke	Medium build-up in nozzle cap due to closing of airflow before needle seating in nozzle	Ensure needle is seated in nozzle before stopping airflow. Practise control
	Damaged needle	Repair, using fine abrasive block, or replace
	Solid particles in nozzle	Remove and clean
	Impurities in airflow	Remove nozzle and clean. Blast air through. Check filter or, if your compressor does not have a filter, consider adding one

Fault finding/2

Problems	Diagnosis	Cure
Spatter at end of stroke	Damaged needle or nozzle	Replace
	Impurities in air supply	Check filter
Blobs at beginning and end of stroke	Needle not seating in nozzle when released	Check needle seating firmly in nozzle
	Needle sticking in channel due to build-up of medium on needle	Remove needle, clean and re-seat
	Poor lever control	Practise
Regular pulse pattern	Pulsating air supply from compressor without reservoir	Fit reservoir to air supply
Irregular pulse pattern	Insoluble solids in medium	Use alternative fine ground medium
	Dirt in nozzle	Remove needle and nozzle, clean and refit
Spidering effect	Airbrush too close to surface	Move further from surface
	Too much medium	Adjust needle control
	Poor lever control	Practise
Inability to produce fine line	Medium too thick	Re-mix with more thinner
	Air pressure incorrect	Adjust air pressure
	Needle bent or damaged	Replace
	Nozzle damaged	Replace

Problems	Diagnosis	Cure
Lever fails to return after being pressed down	Air valve spring fatigued	Stretch the spring or replace it
	Air valve sticking	Remove and clean. If problem recurs, return to agent
Lever fails to return after being drawn back	Needle spring	Remove and re-tension spring by stretching it, or replace
	Build-up of medium on needle where it passes through reservoir	Remove, clean and re-seat
	Lever assembly broken	Return to agent
Air leaks through control lever	Diaphragm (rubber ring in air valve) broken	Return to agent
Air leaks through nozzle when lever released	Air valve spring fatigued or incorrectly tensioned	Re-tension, replace or adjust valve spring retainer
	Air valve sticking	Remove and clean with mild abrasive (metal polish will do)
Air blasts out at high pressure	Pressure of compressor too high	Turn down pressure control. Check pressure regulator
	Canister overblowing	Release pressure until satisfactory
Medium leaks	Reservoir overfilled	Empty reservoir and re-fill without overfilling
	Erratic movement of airbrush	Your action insufficiently controlled
	Washers perished or badly seated	Replace or re-seat
	Nozzle washer missing or damaged	Replace
Flooding of medium on to surface	Medium over-diluted	Remix with more pigment
	Poor airbrush control: ratio of medium/air incorrect	Practise

Airbrushing a cube

Look at the objects around you, and you will find that they are all made up of flat planes and rounded surfaces. These form simple shapes, such as cubes, cylinders and spheres. The exercises on the following pages will show you exactly how to render these shapes, given a fixed source of light. You can then apply these basic principles to almost any object.

For example, a cube could be viewed as a square building, lit by the sun over the viewer's right shoulder. This means that the left-hand face of the building will be in the darkest shadow. The top face will be the lightest, and the right-hand face will have a neutral tone. As the building is viewed in natural light, there will be light reflected from its adjacent surfaces and objects, and the amount of shadow on each plane will vary, creating a graduated tone. It is this interplay of light and shade that defines the planes and creates the shape of an object.

All of the exercises in this section are performed using gouache in shades of black, grey and white, sprayed on to good-quality cartridge paper. When endeavouring to represent solids using light and shade it is important to understand the effects white and black – light and shade – have on the eye. White tends to attract attention and can be used to bring forward particular areas of an illustration. Conversely, black has a passive effect, making areas recede into the distance.

The top – and lightest – surface, with a highlight

Tones
The tones shown here represent an object viewed under normal daylight conditions. When more extreme light sources are used, the tones would alter accordingly.

Neutral grey face, with a slight variation in tone

Area in deepest shadow

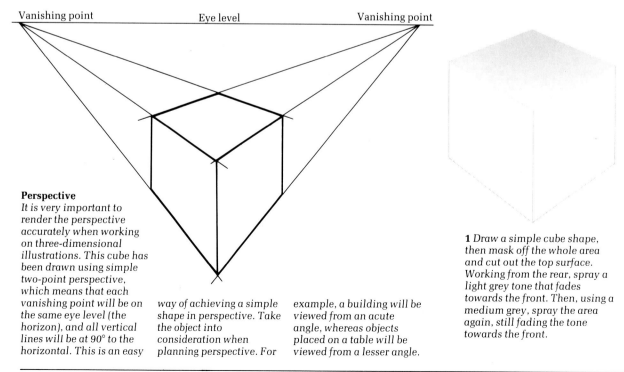

Vanishing point Eye level Vanishing point

Perspective
It is very important to render the perspective accurately when working on three-dimensional illustrations. This cube has been drawn using simple two-point perspective, which means that each vanishing point will be on the same eye level (the horizon), and all vertical lines will be at 90° to the horizontal. This is an easy way of achieving a simple shape in perspective. Take the object into consideration when planning perspective. For example, a building will be viewed from an acute angle, whereas objects placed on a table will be viewed from a lesser angle.

1 Draw a simple cube shape, then mask off the whole area and cut out the top surface. Working from the rear, spray a light grey tone that fades towards the front. Then, using a medium grey, spray the area again, still fading the tone towards the front.

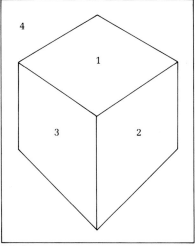

Masking
Planning your masking is an important factor in any airbrush illustration. The order of masking for this simple illustration is shown above.

An alternative finish
You can give the impression of different materials and textures simply by altering the tones and masking sequence of an illustration. This example shows a cube made from a transparent material such as perspex. Render the two inner faces as though the two outer surfaces were removed. Then spray both these faces to give an impression of transparency. Use delicate shades so as not to obscure completely the inner shading. This is the technique used when rendering transparent objects and when 'ghosting' portions of illustrations – the technique frequently seen in prestige illustrations of such objects as cars.

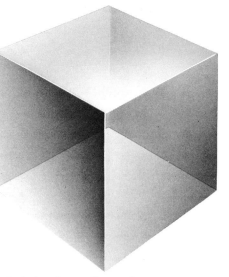

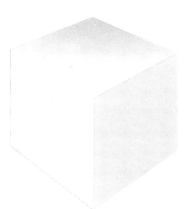

2 Replace the cut-out portion and remove the right-hand face of the cube. Using a mid grey shade, spray a tone, this time fading it slightly from the right-hand edge. Take care not to spray too heavy a tone – a good guide would be to balance the lightest tone with the darkest tone on the top face.

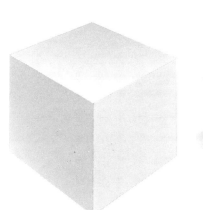

3 Replace the cut-out portion and remove the remaining face. This will be the side in shadow and therefore the darkest. Build up the tones as before, spraying from the top corner and fading to the bottom. Check the balance of shading is correct by lifting up the previously cut masks.

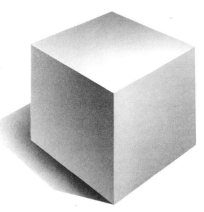

4 Replace the masks then, taking each face in turn, carefully increase the depth of the shadow, using jet black. Now expose the top face and, with permanent white, spray from the front edge towards the back, giving slightly more emphasis to the right-hand edges. Then mask off the entire cube and cut a mask for the cast shadow on the ground. Using a mid grey, spray away from the cube to the furthest edge.

Airbrushing a sphere

Although airbrushing a sphere appears to be quite straightforward, it can be the most difficult of these initial exercises. Because there are no edges, and therefore additional masks are not needed, the impression of form must be built up using freehand spraying alone. This will show you the need for good finger control and also the importance of moving the whole arm – not just the wrist – when reproducing the flowing, regular, curves of the sphere.

The sphere has been painted with a non-reflective surface. It is positioned at ground level with the light source coming from over the observer's right shoulder at an angle of 45° to the ground.

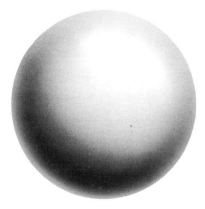

Neutral tone dictating the depth of contrast between the shadow and the highlight areas

Highlight off-centre to the right

Area in deepest shadow, showing slight reflections from the surface on which the sphere is resting

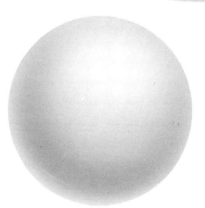

1 *Using a compass, draw a circle approximately 4in (20cm) in diameter, directly on to the ground. Place the masking film over the circle and cut it out freehand. Then begin to build up the tones, applying light grey with steady sweeps of the airbrush. As with the cylinder (see pp38-9), a small amount of light will be reflected from the ground on to the underside of the sphere.*

2 *Continue to build the shadows, using mid grey, and leaving the highlight top right of the centre point. When darkening the shadow areas towards the base, take care to retain the lighter tones towards the base as well. You must make sure that you control your airbrush carefully, holding it not less than ½in (1.3cm) from the ground.*

3 *With the basic tones completed, carefully finish the shadow area using thinned jet black applied sparingly. Finally, clean the airbrush thoroughly and, using permanent white, carefully increase the highlight area to complete the illustration.*

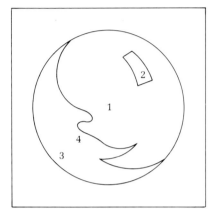

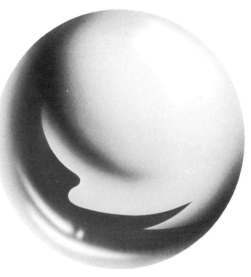

Masking
When working on the non-reflective sphere, simply cut a circle from a sheet of masking film, using a scalpel attached to a ruling pen compass. For the reflective sphere, cut masks as shown above, and spray the areas in the sequence indicated. As always, the largest area should be sprayed first, working then to the finer detail – in this case, the shadows.

An alternative finish
When attempting to represent a highly polished surface – in this case, a ball bearing – it is important to plan the shapes and patterns of the reflections and shadows carefully before beginning any spraying. For this

illustration I chose dark, heavy shading with incidental reflections and highlights to add interest to the form. This requires careful hard masking with masking film. The highlight flashes are sprayed freehand.

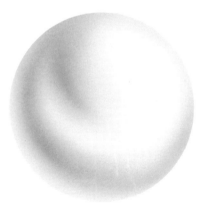

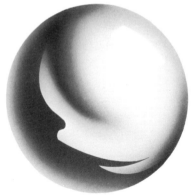

1 Draw a circle directly on to the ground and place masking film over it. Cut out the area, leaving a portion of the film to act as a highlight. Mix a light grey shade and build up the basic tones, using smooth freehand sweeps of the airbrush.

2 Using mid grey, continue to build up the basic shadow areas, leaving the mask on the highlight untouched.

3 Replace the mask cut out in 1 and cut out the shape of the shadow. Spray with jet black from the hard edge of the shadow towards the base, leaving some reflected light at the base. Remove the mask, soften the edges at the top and spray freehand a sweeping shadow to the centre of the sphere. Remove the highlight mask and, using permanent white, soften the top edge of the highlight. Then add the flashes of reflected light.

Airbrushing a cylinder

Cylinders, like cubes, are shapes common to many everyday objects in the home and elsewhere, from pens, bottles, lampshades, pots and pans to factory chimneys, aircraft and rockets. All these subjects can be rendered effectively and convincingly once you have understood the basic guidelines for illustrating cylinders, which are given in this exercise.

When representing a cylinder as a solid, the principles of light attracting the eye and black receding into the distance become more apparent. These rules will enable you to illustrate the correct form of the cylinder. If you want to represent the cylinder as transparent – made of glass, for example – follow the instructions at the end of this section (see pp42-3).

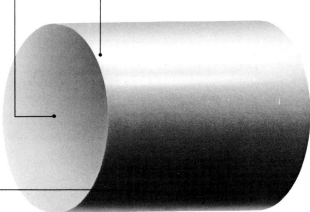

Graduated tone on the shadow area contrasting with the highlight

Highlight with added flash

Area in deepest shadow with slight reflection from the surface

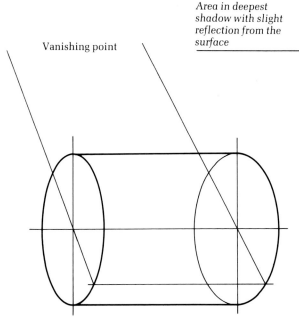

Vanishing point

Vanishing point

Perspective
When drawing a cylinder viewed side on (above), there is only one vanishing point. Whatever the length of cylinder, if it were drawn in true perspective, the two ellipses forming the cylinder ends would be of different angles. These can be determined by projecting lines to an imaginary vanishing point through the centres of the ellipses. The points where these lines cut
the edge of the ellipse would be parallel to the centre line. These rules also apply if the cylinder is viewed at an angle (right). However, for a true perspective view, the cylinder will have three vanishing points in total. You may find it easier to draw a rectangle in the desired perspective, using two vanishing points, as in the cube exercise (see pp34-5). The third vanishing point will be created by bisecting
the rhombuses at either end of the rectangle. This gives the major axis of the ellipse. By joining the other two corners of the rhombuses,
you will produce the minor axis. Ellipses can then be drawn at either end of the rectangle and joined up to produce a cylinder.

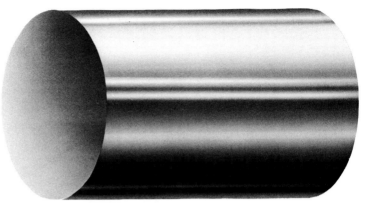

Masking

When planning the masking procedure of an illustration of a cylinder, follow the numbered sequence shown in the diagram (below). You must keep all the cut masks if you intend to add tone to the background, whether it is a shadow area or a soft gradation. When you replace the masks to spray the tone you will have exact shapes around which to work. If you airbrush the cylinder with the reflective surface, use a loose mask (4) to produce the sharp edges of the reflections.

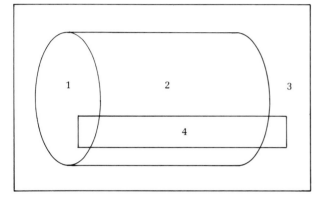

An alternative finish

In order to render this highly polished cylinder I used the same principles as those described in the step-by-step instructions, with the highlight above centre and reflected light at the base. You can change the appearance – and therefore the finish – of the cylinder simply by hardening the lines and increasing the contrast. To do this, use loose masks of cartridge paper to render the hard edges and introduce reflections into the shadow areas.

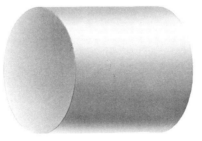

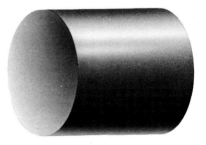

1 Lay the masking film over the drawing and cut out the curved area of the cylinder. With the airbrush close to the ground, spray a light grey tone along the cylinder, from a point slightly above the edge and fading to a point just above the centre line. Then spray a graduated tone from the top edge, fading towards the centre, to leave a highlight above the centre. Replace the mask and cut out the end section of the cylinder. Spray a light grey tone over the entire area.

2 Repeat the procedure, using mid grey. This time, however, increase the depth of the shadow at the bottom of the curve, remembering to leave an area of reflected light at the base.

3 Using jet black, build up the shadow areas, taking care to spray parallel to the edge. This is especially important where changes of tone are close together, as in the reflected area on the bottom edge. If you find this difficult, try spraying against a ruler held at an angle to the ground. This will give you a straight, yet nicely diffused, edge. Finish your illustration by adding a highlight of permanent white.

Airbrushing a bowl

This exercise teaches you how to render the concave and convex surfaces found in any number of everyday objects, using a bowl as the example. The shape of the bowl is built up using freehand spraying (see pp36-7) in order to develop its shape and define the difference between the inner and outer surfaces.

In this example the bowl has been given a non-reflective, earthenware surface, and the light source emanates from over the viewer's shoulder at an angle of 45° to the ground.

Shadow contrasting with highlight on the outer edge

Reflected light from the surface on which the bowl rests

Highlight area diagonally opposite that on convex surface of the bowl

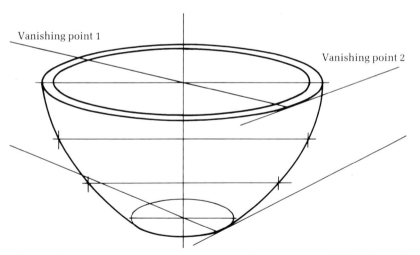

Vanishing point 1

Vanishing point 2

Perspective
To construct the two ellipses at the top of the bowl, mark off both the major and minor axes and, using the trammel method (see pp24-5), plot the curves. Now plot the inner ellipse and its minor axis. The ellipse at the bottom of the bowl will be at a slightly greater angle than the two at the top, and you should estimate this new angle by eye. In order to check that you have done this
correctly, project a straight line through the centre of the ellipse and draw a tangent at the point of intersection. This should project to the second vanishing point on the horizon. The sides in this straight-on view of the bowl will be equal. Draw two lines parallel with the major axis of the ellipse and mark off equal distances from the centre. Using a French curve, draw in the lines you find most pleasing.

1 *Having traced the accurate outline of the bowl on to the ground, cover it with a sheet of masking film. Cut out the outer convex surface and, using light grey gouache, begin spraying the basic tones. Remember that the reflected light from the ground will be apparent on the underside of the bowl.*

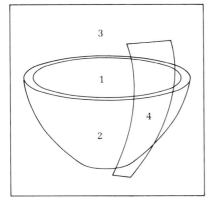

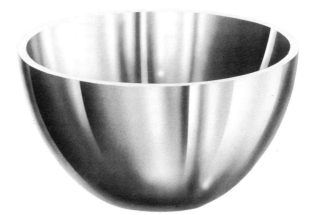

Masking

The masking procedure for the bowl is relatively simple, requiring only accurate freehand cutting of the curved surfaces. When using loose masks for the metallic finish, cut each curve according to its position on the bowl.

An alternative finish

In this example the composition of the bowl has changed from earthenware to brushed stainless steel. This will give you greater scope in the use of hard and soft masking and freehand spraying of the highlights and reflections. Although

this illustration seems quite complex, the basic shadows and highlight areas remain the same as those on the earthenware bowl in the main example. The only difference is that some sharp and some random reflected highlights have been added.

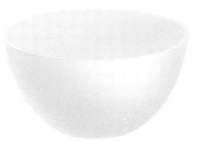

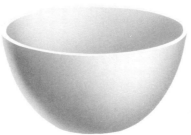

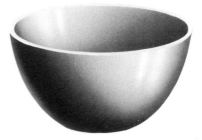

2 Replace the mask and cut out the inner, concave, area, including the lip of the bowl. Spray a flat tone over the entire area. Now cut out the inner concave area only and build up the shadows using a light grey tone. Bear in mind that the area of highlight will appear on the opposite side to the outer convex surface.

3 Using mid grey, continue to build up the shadow areas, using freehand spraying. Accentuate the shadow at the base of the bowl. You must also increase the shading on the inner concave surface to contrast with the highlight on the outer surface.

4 Complete the shading, using jet black, and remembering to allow for a certain amount of reflected light on the left-hand underside of the bowl. Finish the illustration by adding highlights in permanent white. Rather than applying a soft highlight, try adding a sharper reflected highlight by working close to the ground.

Planning a still life

To conclude these introductory exercises, four basic geometric shapes have been combined in a still life study. Each one has been rendered to represent a particular surface texture – glass for the cylinder, polished steel for the cone, smooth plastic for the cube, and stone for the sphere.

This exercise also introduces colour for the first time. You may find this intimidating at first, but if you follow the guidelines set out in the previous exercises, working with colour will become perfectly straightforward. It will also give you much more scope in your future airbrush projects.

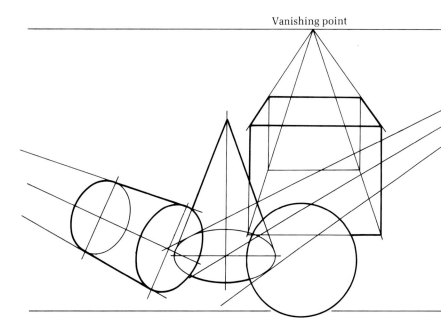

Vanishing point Vanishing point

Perspective
This diagram illustrates the careful planning needed when composing the arrangement of a still life. It shows the importance of maintaining consistency in the perspective vanishing points. All of these, whether two-point – as in the cylinder – or one-point – as in the cube and cone – must be positioned on the horizon. All vertical lines are at 90° to the horizontal.

1 *Mask off the whole drawing, then cut out and remove the cube section. Spray a thin tone of cadmium red over the entire area. Place a loose mask over the top face of the cube and spray away from the mask to build up the colour on the front face of the cube. Now loosely mask the front face and spray the top. Using red ochre, build up the existing tones. With the same colour, and using loose masks, add the reflections of the cone and sphere.*

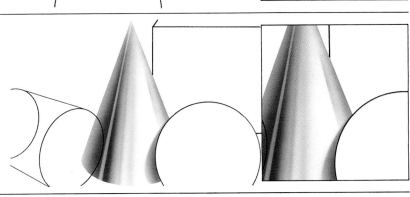

2 *Cut a mask for the cone, including the section behind the cylinder. Spray the basic tones in cerulean blue. Continue to build up the tones, using Payne's grey and loose masks for the hard edges. When adding the shadow cast by the sphere, cut a mask from stiff cartridge paper and move it gently while spraying to give a softer edge to the shadow. Use jet black to complete the shadows and permanent white for the highlight. Then spray red into the highlight as a reflection from the cube.*

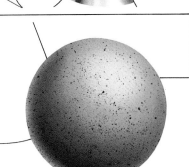

3 *Having masked off the sphere, mix yellow ochre and spray the basic tones (see pp36-7). Then, using a spatter technique (see pp70-5), carefully add the texture with Vandyke brown, followed by red ochre. Finally, increase the density of the shadows by overspraying Vandyke brown and the highlight using permanent white.*

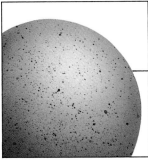

4 *Mask off the cylinder and cut out the back curved area. Spray the contours with Davy's grey, using loose masks for the hard edges. Replace the mask and cut out the rear ellipse. Using the same grey, apply a tone that fades from the top towards the bottom. Using a new mask cut out the front ellipse. Lightly spray the whole area, emphasizing the top edge. Replace the mask and cut out the curved front portion. Overspray this area, treating it as though it were a normal solid cylinder.*

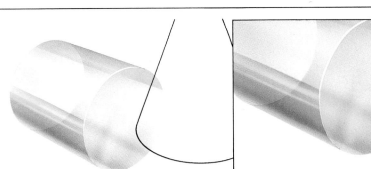

Practical projects

The projects in this section are designed to broaden your knowledge and experience, now that you have mastered the basic techniques of airbrushing. Beginning with a relatively simple landscape, and following each project through, you can produce attractive illustrations that will extend your knowledge of airbrushing techniques. You can trace over the line drawing at the beginning of each project to obtain the initial outline from which to work.

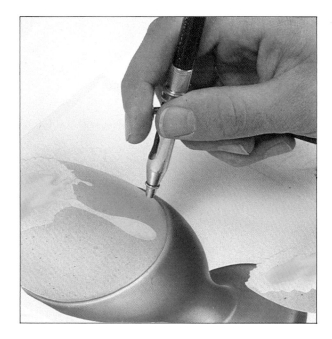

Learning from landscape

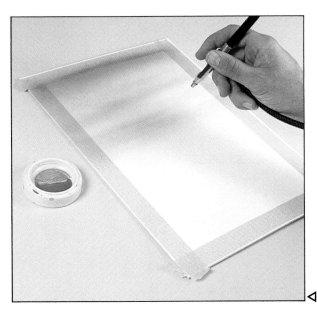

This is an easy project, designed to build up your confidence and airbrushing expertise. It should also help to give you an understanding of how loose masking can be used to create a straightforward, yet interesting, picture. Though very simple to execute, the finished design gives a most pleasing image that demonstrates the airbrush's obvious advantage over other media in producing smooth graduated tones.

Once you have mastered the project as illustrated here, try illustrating the scene again, but this time at sunset. If you need reference to help you, look at photographs in books and magazines – these help you choose appropriate colours and hues.

1 Prepare the line board by cleaning it with cotton wool soaked in lighter fuel to remove any particles of grease. Mask the area to be sprayed with strips of masking tape. Choose the colour of gouache you wish to use for the sky and begin spraying, working from the top of the picture and fading down to the horizon – a suitable point could be halfway down the page. Vary the tones to create an interesting, streaked, sky. ◁ Continue building up the density until you are happy.

2 Choose a suitable dark colour for the mountains. To make a loose mask for the mountains, take a stiff piece of card or paper, and tear it roughly to create a suitable shape. Lay this mask over the sky area, or the position of the horizon and begin spraying away from the card, taking care not to spray too heavily. Keep the tones fairly light at this stage to achieve the effect of distance. Make frequent checks by lifting the mask until you are happy with your painting. ▷

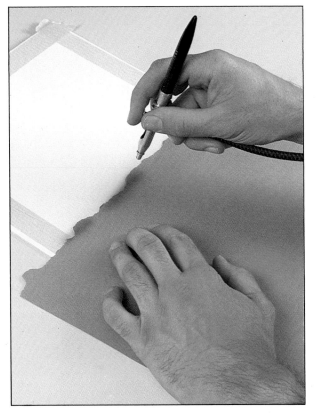

3 You can lay one mask over the other to create a more mountainous effect. Hold the two masks firmly in place and spray away from them, using the same colour as in **2**, but making the tone slightly darker.

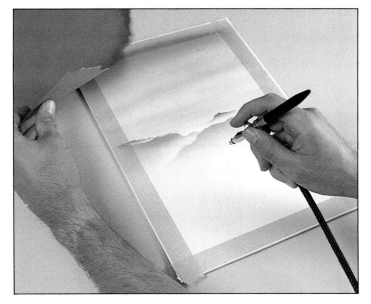

4 Remove the loose masks to check your spraying. You must now begin work on the middle distance, working without masks. As you work, ensure that the tones darken towards the foreground to achieve the correct impression of perspective. ▷

5 Lay another mask in the foreground. Add a black or charcoal grey to the paint mix to get an even deeper tone. Continue spraying the foreground, darkening the paint and the density of the spray at each stage, until the graduated tones of the mountains give the effect of depth.

The finished artwork
Carefully remove the masking tape and fix the entire picture by spraying it with a solution of equal amounts of gum arabic and water mixed in an old palette. Not only does this protect the image, but it also gives lustre and depth to the paint. When you have finished, immediately clean the airbrush thoroughly with clear water until all traces of the fixative have gone. ▷

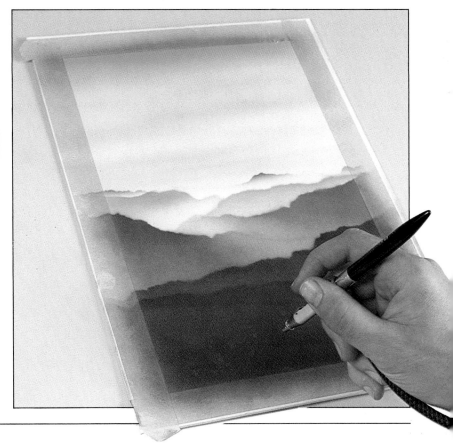

Three dimensions/1

This project uses tones to create a three-dimensional form, allowing you to develop an understanding of light and shade. It also demonstrates how their use can bring areas of your image forward or make them recede. In addition, it introduces masking with low-tack adhesive film, combining this with the loose masking used in the previous project. The subject is typical of the technical illustrations that an airbrush is frequently used to produce.

It is relatively easy, too, to convert the 'straight on' view illustrated here to a three-quarters perspective view. Because you will now see the top surfaces of the nut and bolt, this involves drawing ellipses (see pp24-25). Build up the tones, shadows and highlights in the same way as you did before, but, when spraying the shadows and highlights on the top surfaces of the bolt head and nut, make sure that the direction of the light source corresponds to that indicated by the shadows and highlights on the bolt shank and threads.

It is also worth bringing some colour into the treatment. Using blue for the lighter tones will give your image a more metallic look; using yellow and brown give the impression of brass.

1 Transfer the line drawing of the nut and bolt on this page on to tracing paper using the grid method (see pp24-5). Then, using tracing down paper, trace it on to the cleaned line board with a hard pencil, such as a 9H, or a blunt steel point. Lay the low-tack adhesive film over the two areas to be sprayed – in this case, the heads of the nut and bolt, but not the shank. Cut out the masks.

To make the illustration look realistic, the nut and bolt must show light and shade, so choose the direction of the light source, either in your mind or by making a thumbnail sketch on a separate piece of paper. Plan the shaded and highlighted areas accordingly. Begin spraying the darker areas of the bolt head and nut 'flats' in light grey, using a loose paper mask to define the planes. Remember always to spray away from the mask, otherwise paint will creep underneath it. ▷

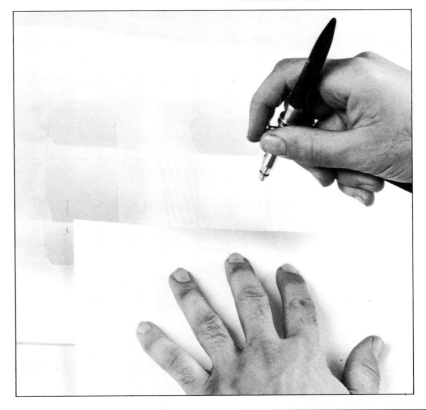

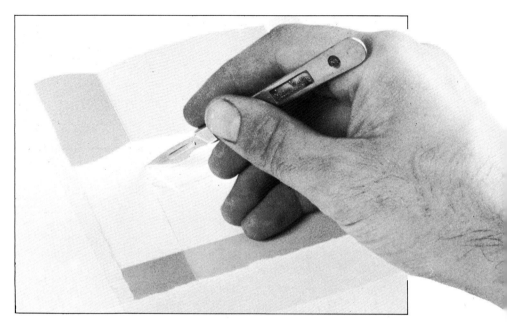

2 When you are satisfied with the depth of shading, remove the two masks, keeping them to one side as you will need them again later. Lay a further mask to cover the shank. Carefully cut out the threaded section. You can use a steel rule to guide you when cutting the threads with a scalpel, but it is best to use a scalpel freehand if possible, so that you can feel the pressure you are exerting on the film. Then you will only cut the film and not score the board. This takes practice but it is well worthwhile persevering until you have mastered the technique. ▷

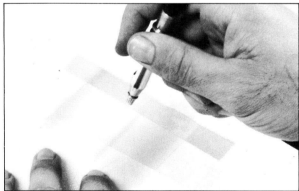

3 Mask the shank of the nut and build up the tones to give the impression of a cylinder *(see pp34-5)*. Because the nut and bolt have shiny machined surfaces, the contrast is shown by a hard line on the shadow side of the shank. Hold the airbrush close to the paper to achieve this. To create an even sharper, harder, line, two loose paper masks could be used and the colour sprayed between both of them.

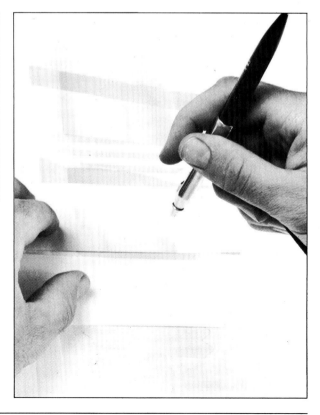

4 Now concentrate on the threaded portion of the shank. Mix a darker shade of grey and begin to build the shadow on the underneath section of the thread, using two loose paper masks and working down the thread, maintaining a consistent tone for each thread. Check the density of the spray at frequent intervals. ▷

Three dimensions/2

5 To create the shadow area on the shank beneath the head of the nut and bolt, use another loose paper mask. This time, cut it to the shape of an arc to give the impression of a shadow falling on the cylinder. Spray away from the mask, retaining the balance of light and shade by keeping a correct balance of shadow between that of the arc and the longitudinal shadow. ▷

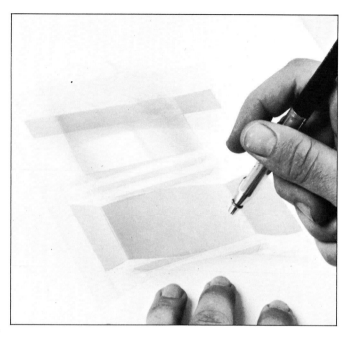

6 Once you have completed the threaded area and are happy with the general balance of the illustration so far, you can now build the tones. Use a darker grey and loose paper masks to increase the depth of the shading areas. ▽

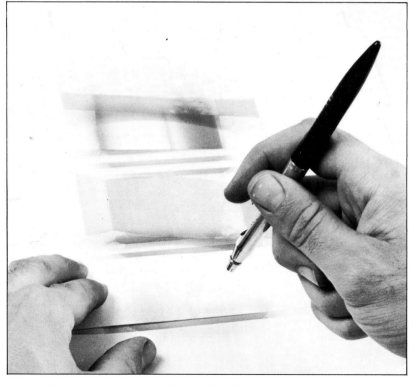

7 Remove the adhesive film to check that the depth of shadow is correct. If so, move on to the next step. If the shadow is not right, it is easy to reposition the mask and continue spraying the tone.

8 Reposition the masks which were used in **1**, to reveal the heads of the nut and bolt. ▽

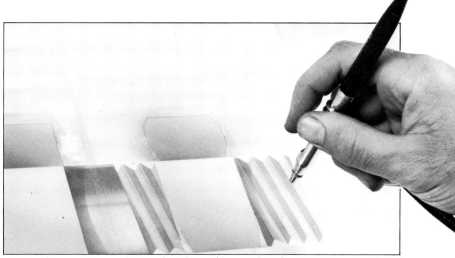

9 Use the same tone as that used on the threaded areas to build the shadows on the heads of the nut and bolt, until they match in density. To increase the contrast, you can introduce white to the highlight areas.

The finished artwork
Having completed all the spraying, you can put the finishing touches to the picture. Clean up the edges and build up sharp highlights on the edge of the threads and other suitable areas, using a fine sable brush and white gouache. Fix the illustration by spraying it with a solution of equal amounts of gum arabic and water. Remember to clean the airbrush after using the fixative.

Creating a rose/1

This is a good project for a beginner, firstly because it combines the use of adhesive and loose masking, and secondly, because it gives you the scope to exercise your own imagination. There are many hundreds of different roses, and no one standard example. Painting the rose also gives the artist the opportunity to practise freehand spraying when creating the petal formation.

Here, gouache was used to spray the image. However, you may prefer the translucent quality of watercolour to the opaque quality gouache produces, so try the project using both media. If you use watercolours, the way in which you build up tones can be reversed. This means starting with the shadows and then building up the lighter areas around them.

Whichever medium you choose, it is worth planning the boundaries of the various tonal areas carefully beforehand, as otherwise the inevitable overspray that occurs when several masks are used may confuse you when it comes to defining the shadows. Take the full-size tracing of the rose and, having decided on the direction of the light source, shade in the shadow area in pencil. Follow this guide carefully as you build up the picture; misjudged or wrongly positioned tones will rob the illustration of depth and clarity.

1 Transfer the line drawing of the rose given here, or one you have drawn yourself, on to a piece of tracing paper, using the grid method (see pp24-5), and then, using tracing down paper, on to a piece of clean line board. Cover the entire area of the rose with masking film and cut out the complete petal area, keeping the cut-out piece for use later. Spray to give the overall base colour of the rose. At this stage, you need only give the petal area a very pale covering of grenadine. ▷

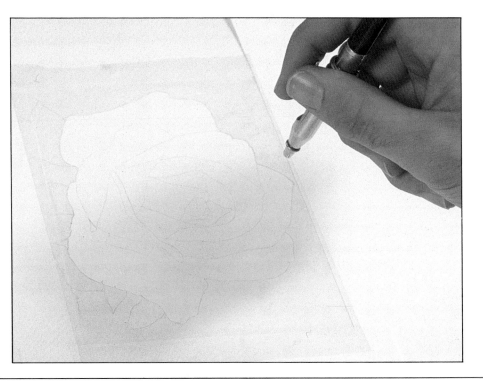

2 Replace the mask that you removed in **1**. Use the point of your scalpel blade to position a corner of the mask accurately, taking care not to damage the sprayed surface underneath it. ▷

3 Cut out one of the petals at the outer edge of the rose, and keep the cut film to one side. ▽

4 To build up the tones in each petal, start spraying with the same colour you used on the overall wash in **1**, but increase the density to build up the shadow areas. ▷

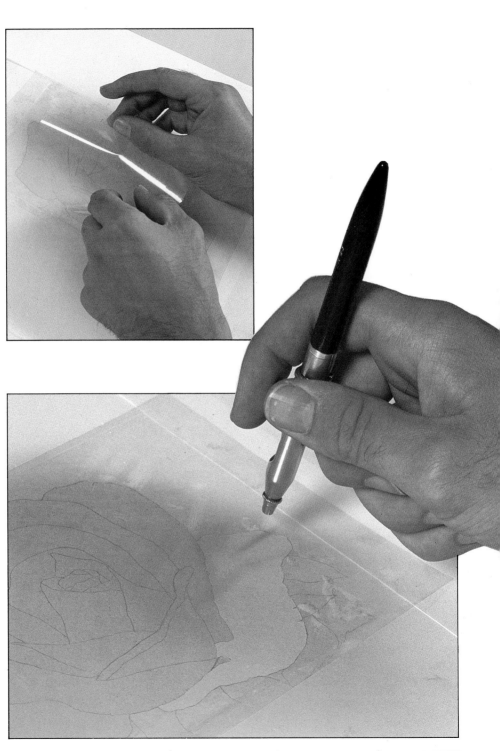

Creating a rose/2

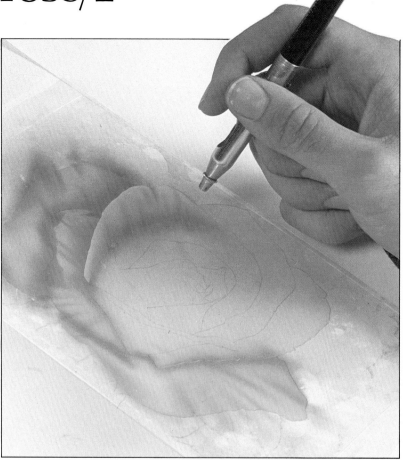

5 Continue the build-up of tones until you are satisfied with the depth of colour and the shape of the folds of the petal you have created. ▽

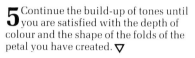

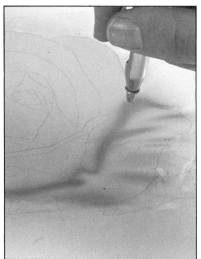

6 Repeat the process for each petal area, replacing the cut-outs already worked on and removing the next cut-out, until all of the petal area has been defined. At this stage you must look at the overall effect and, if necessary, build up the tones using a mixture of grenadine and burnt umber.

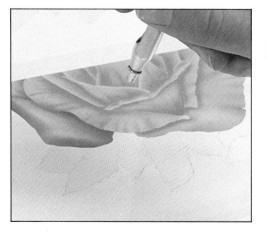

7 Mask off the leaf area and apply a light covering of leaf green. ◁

8 To define the leaves, replace the mask cut in **7** and cut out each individual leaf. Cut a loose mask of paper into a curved shape. By choosing different sections of the curve, you can build up the contours of the leaf to show the curves and veins. Take care to spray away from the edge of the mask. Continue to build up the contours of the leaf, using overlapping loose paper masks, and spraying the darker tones of green. Remember that leaves that are overlapped look darker than those in the foreground of the picture, so that by darkening you will create an impression of distance. ▷▷

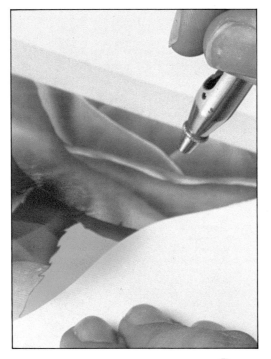

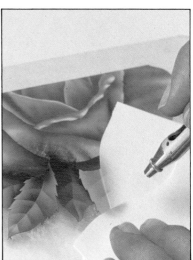

The finished artwork
It may be necessary to lighten or darken particular areas of the rose once the masks have been removed and the overall picture revealed. In this illustration, once the masks were removed, I decided to use careful freehand spraying to build highlights using white, and to darken other areas of the rose. When you have finished working, fix the picture by spraying it with an equal mixture of gum arabic and water. Clean the airbrush thoroughly after use.

Freehand spraying/1

Working on this project is a useful introduction to the freehand spraying of an area of opaque glass. A simple mask is used to define the outer edges of the bulb, the actual shape being defined entirely by masked shadow and highlight areas.

The lightbulb offers a good contrast in textures, with diffused shading on the bulb itself, and the very detailed work on the screw fitting at its base. Having worked through the project – with an opaque bulb it is relatively simple to achieve a pleasing result – you can take it a stage further by illustrating a clear bulb, taking reference from life. With a transparent three-dimensional object, you create the image by painting the shadows and highlights you see through the glass. Study the last project in this section (see pp82-9) to see how to paint clear glass.

With a clear lightbulb, the filament naturally will be visible. The thin wires of the filament demand fine, delicate brushwork, so draw them as accurately as you can on your initial tracing and follow this closely. The glass posts holding the filament can be rendered simply, using a paper mask to spray a shadow and highlight on each post.

1 Transfer the line drawing shown here on to the line board in the usual way, using the grid method (see pp24-5). Mix up a neutral light grey shade of gouache. Choose the direction of the light source, working from photographic reference or a real lightbulb if necessary. Then mask off the glass area and gradually begin to build up the basic tones. ▷

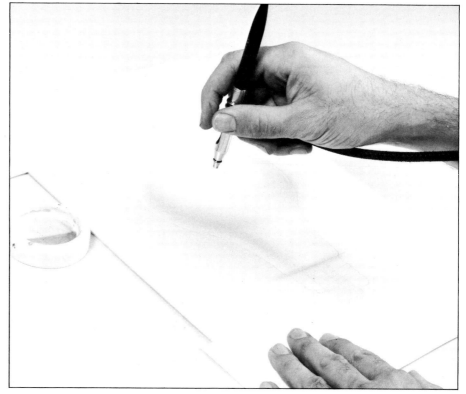

2 Mix a slightly darker tone of grey and begin to intensify the shaded areas. Add extra reflected details where suitable. ▷

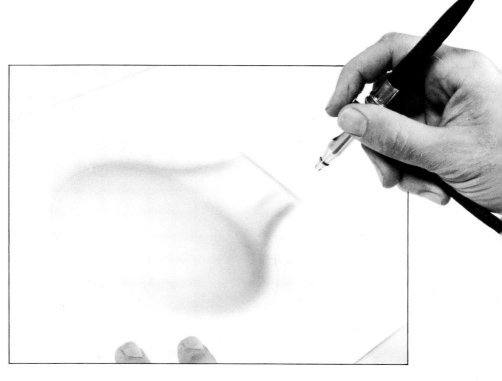

3 Working freehand, continue to build up the shaded areas. The shape of the lightbulb is shown by a combination of soft shading and harder lines. Hold the airbrush furthest away from the board when working on diffused shading, and hold it closest to the board for more defined work. Add the highlights in permanent white. ▽

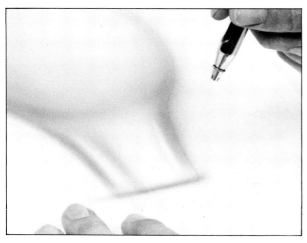

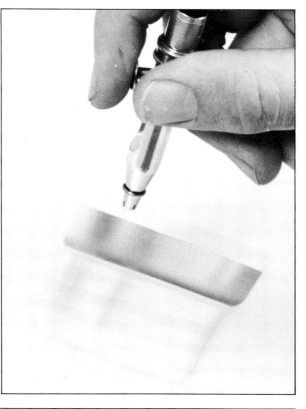

4 Cut a mask for the metal screw fitting at the base of the lightbulb. Mask off the threaded portion and work only on the cylindrical section. Spray a light tone to build the shadow areas, giving the base its cylindrical shape. Remember to keep the direction of the light source consistent. ▷

Freehand spraying/2

6 Add a dark grey to give the shadow a greater depth. Then, using a new mask, cut out the threads and spray each one in turn with a shadow tone. Leave a highlight towards the bottom of each thread, working on the principles given for the cylinder *(see pp38-9).* ▷

5 Using a deeper grey, continue to build up the tones gradually. To paint the insulation plate at the base of the lightbulb, mask off the area and spray with dark grey.

7 Replace the original mask of the cylindrical section. Now paint in the sharp shadow areas, using black. When working on these areas, use a steel ruler as a guide. Hold the ruler at an angle of approximately 45° to the board. Rest the knurled rim of the nozzle cap gently against the edge of the ruler, then carefully release the paint to produce a pencil-thin line. ▷

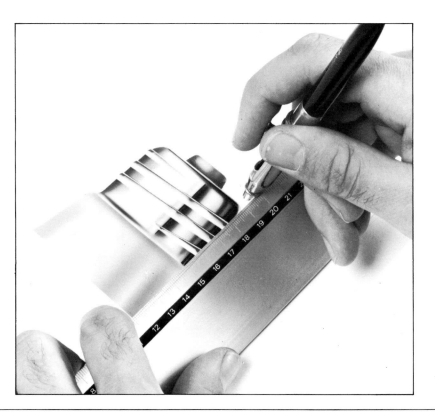

8 Having finished all the spraying, begin lining. Using a ruler as a guide, paint in the sharp shadow detail on the underside of the threads with a fine sable brush and black gouache. There is no need to add white for the highlights as the white of the line board shows through and provides the highlights. ◁

The finished artwork
Put the finishing touches to the illustration, adding highlights or extra shading where necessary. Then fix the artwork by spraying it with an equal mixture of gum arabic and water. When you have finished, clean your airbrush thoroughly to remove all traces of fixative.

Practical perspective/1

This project is a good exercise in perspective; it is also much simpler than it looks to create. The image is built up using flat planes of colour and straight lines, and only a basic knowledge of two-point perspective is required. If you choose not to use the line drawing given here as reference and decide to draw the matches from a different angle instead, you can check to see if the perspective is correct by holding up your drawing in front of a mirror.

This project also introduces hand lettering, because it calls for a hand-lettered design to be painted on to the flap of the book of matches with a fine sable brush. However, hand lettering is not easy to execute – it needs considerable care and practice to achieve a good result – while drawing it in accurate perspective is an added difficulty. If you lack confidence at this stage, or think you may spoil the finished artwork, choose a simple graphic image in contrasting colours for the front flap. In either case, you will find it useful to have a real book of matches beside you as you work, to use as a reference. You can shine a light on to the matches from the desired angle, too; this will help you plan the areas of light and shade in the illustration.

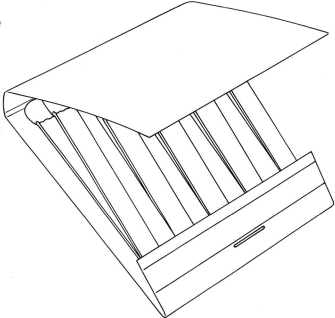

1 Transfer the line drawing of the book of matches on to tracing paper, using the grid method (*see pp24-5*), then transfer it to the cleaned line board, using tracing down paper. Lay the adhesive masking film and cut out the largest area. Spray the first tone in permanent green light. ▷

2 Now build up the shadow areas using the next darkest tone – permanent green middle. Use a loose mask to reveal the shaded area at the base of the book of matches. This area would not have a sharp edge, so create a subtle, soft edge by moving the loose mask backwards and forwards very slightly while spraying. ▽

3 Cut a new mask to reveal the matches, but excluding the match heads, then spray a base tone in charcoal grey.

4 Use another loose paper mask to develop the shade on the matches. Move the mask along as you work, to define the individual matches and show their relationship to each other using light and shade. Spray away from the paper mask to stop the paint seeping under it. Keep the airbrush close to the board because this is relatively detailed work and the individual areas to be sprayed are small. ▷

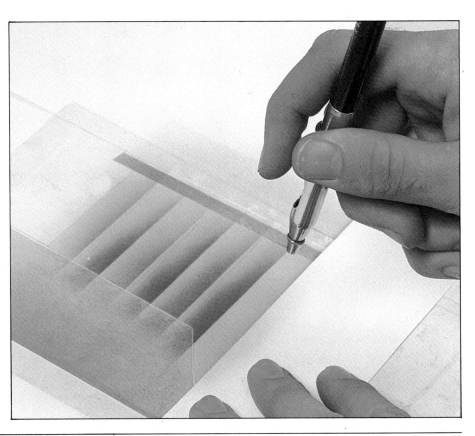

Practical perspective/2

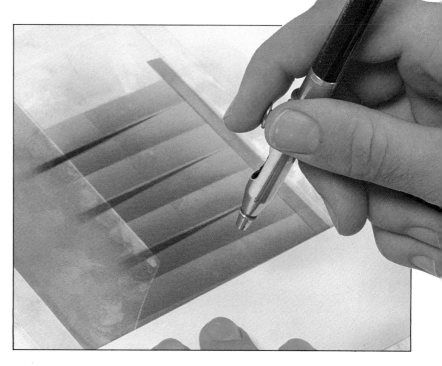

5 Continue to build up the tones of the matches. Work the deep shadow areas using overlapping paper masks. To paint the shadow cast by the flap on to the matches, plan the shadow first on a tracing paper overlay, then trace it, using a transfer sheet, on to the line of matches. Then lay the adhesive film and cut out a mask to size. Spray the dark tone. Remember that the areas nearest the flap will be the darkest, graduating out to the end of the shadow, which will be a lighter grey. ▷

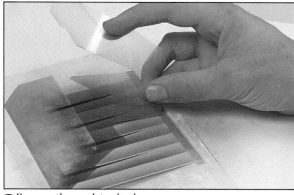

6 Remove the mask to check the shadow. Continue spraying if necessary.

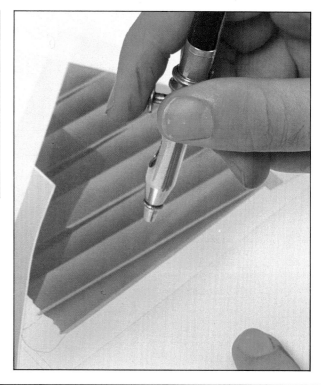

7 Mask off the underneath of the card. Mix up a tone of Davy's grey, which has a hint of green. This colour contrasts well with the deep grey of the matches and the green of the flap. ▷

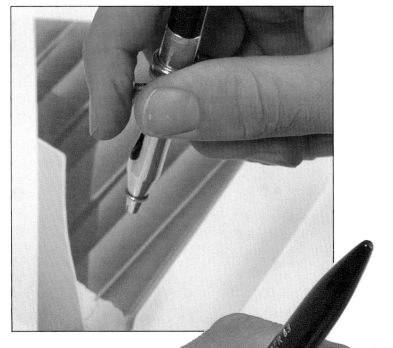

8 Spray the shadow areas cast by the matches, using loose masks. Use the same colour as that cast by the flap, but increase the density of the spray. ▷

9 Mask off the match heads and spray them with a base red, using close-up freehand airbrushing. Build up their shape, leaving highlights in the appropriate areas. If you are not confident enough to spray the match heads freehand, cut loose masks and use them as a guide. ▷

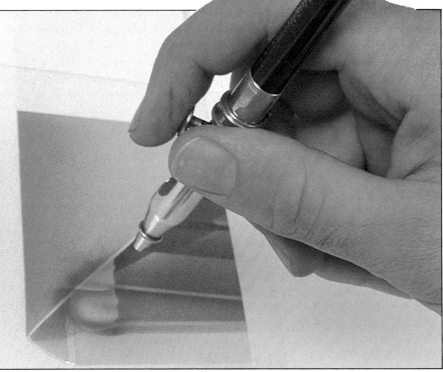

10 Now mask off the striking strip. Because this is a non-reflecting surface there will be little contrast of tones, and you can spray the brown tint evenly across the strip. ▽

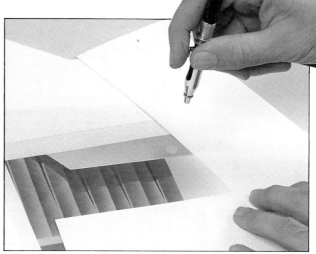

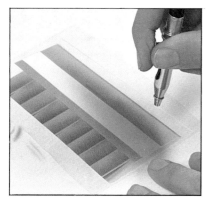

11 To make the illustration look realistic, you must give the impression that the book of matches is lying on a flat surface. Cover the book of matches with adhesive film and cut loose masks to define the surface on which it is resting. Lay a cast shadow in a neutral grey, slightly moving the loose masks during spraying to soften the outer edges of the illustration.

The finished artwork
To complete the illustration, choose a simple design for the flap – typography or graphics. Draft the accurate design on to the original tracing, then transfer it, using the transfer sheet, on to the illustration. Paint in the design by hand, using a fine sable brush and a suitable colour in gouache. Here I used a mixture of raw umber and cadmium yellow to give gold. When this has dried, fix the illustration with a solution of gum arabic.

Using watercolours/1

For this project you can use transparent watercolours instead of opaque gouache. This means that you can reverse the usual painting process and work from dark to light – painting the shadow areas first and then building tone around them.

Before starting work on the project, it is important to plan the reflections and shadows. Chrome is a difficult subject to represent, especially as you are aiming for a realistic result. Study the shapes created on the taps in your kitchen or bathroom and use them as a guide when planning the illustration, and then draw in the reflections on your full size tracing. It is important to draw these as accurately as possible; because chrome has a fully reflective surface, it is only by utilizing these that you will be able to give your illustration form and shape.

You can add interest to the illustration by using colour in the reflections. If you are drawing from life, take note of the reflected colours of objects close to the tap, though you should be careful how you use them, since they can look odd when seen in isolation. If in doubt, use light blue for reflections on the top surfaces and mid- to dark brown for the lower surfaces.

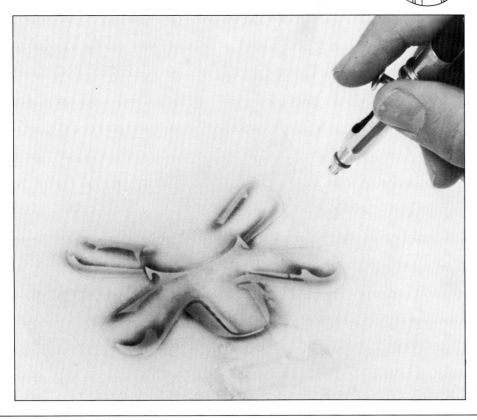

1 Transfer the line drawing shown here on to tracing paper line board, using the grid method (see pp24-5), and then on to clean line board. Include in line form the areas of dark shadow and transfer these to the board at the same time as the outline. Lay some masking film over the head of the tap and cut it to reveal all the shadow areas. Mix a charcoal grey quite thinly, and spray, strengthening the areas of darkest shadow. Using jet black, accentuate the darkest tones again, leaving sections of the grey showing through. The black gives a depth to the shadow which would be missing if only one colour were used.

◁

Using watercolours/2

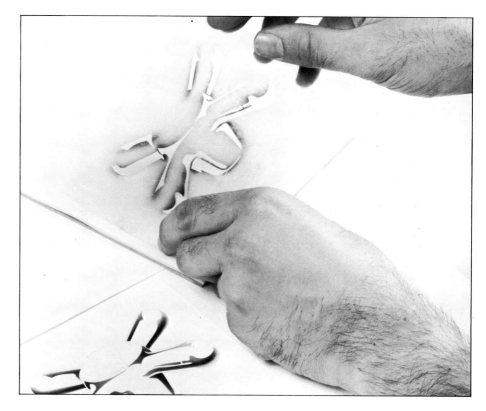

2 Remove the mask, and keep it to one side, as it will be used again at a later stage. You will find it useful to keep a tracing pad beside you, so that you can store the masks between the sheets of paper in a logical order when they are not being used. ▷

3 Mask off the central portion of the tap and cut out the darkest areas. Spray freehand with charcoal grey, remembering the direction of the light source. ▷

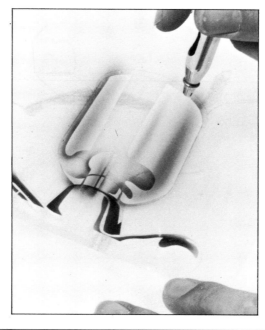

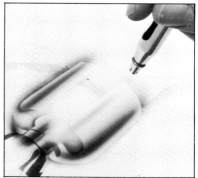

4 Using jet black, intensify the shadow areas, ensuring that you are achieving a reasonable balance with the areas already sprayed.

5 Remove the mask for the tap housing. Now cut a mask for the bottom section of the tap, and spray the shaded areas with charcoal grey. Where two flat surfaces meet, such as those of the hexagonal nut, use a loose mask to define the edges. ▷

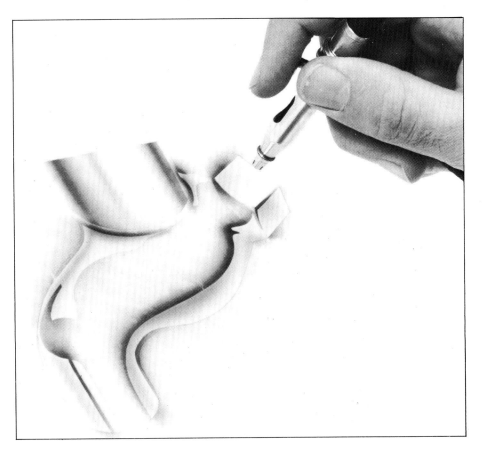

6 Intensify the shadow areas of the hexagonal nut using jet black. A loose mask will define the edge of the nut. Keep a constant check on the depth of the shading against that of the rest of the illustration to ensure a balanced result. ◁

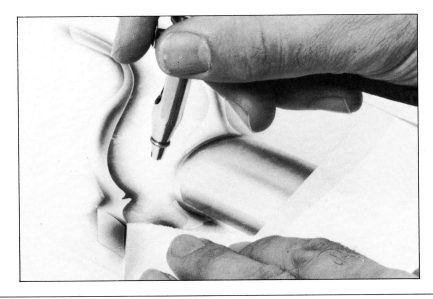

Using watercolours/3

7 Remove the mask from the bottom section of the tap. Only when you are satisfied that the correct shading balance has been achieved should you go on to the next step. ▽

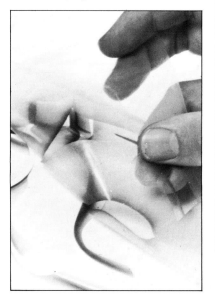

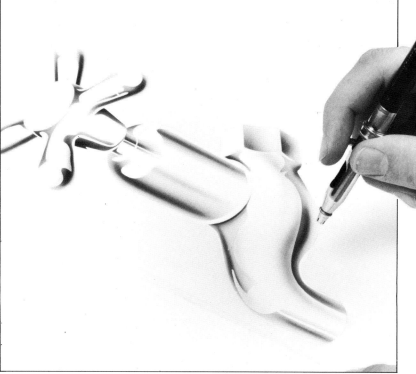

8 To build up the shape of the tap, cut out its complete outline on a new piece of film. Using a thin mix of charcoal grey, build up the form with freehand spraying. Spray over existing shaded areas to intensify the depth.

9 Continue to intensify the shading all the way round the tap. Work freehand, and where necessary, use a ruler as a guide to give you straight, sharp lines. Add the white highlights using permanent white gouache. Work very close to the line board in order to obtain the sharp outlines: ▷▷

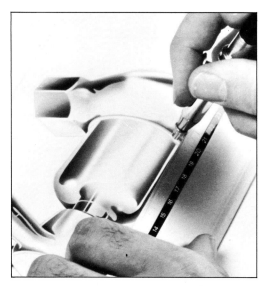

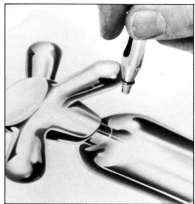

10 To apply the finishing touches, mask off the top ceramic piece at the head of the tap, and spray delicate areas of shading to give shape to the area, while retaining the impression of white ceramic. ▽

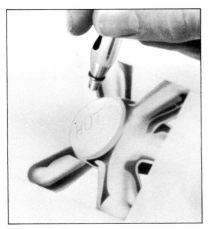

11 Now paint the lettering on the ceramic top, using a fine sable brush and jet black paint. If necessary, use a ruler to guide the brush when painting the uprights of the letters, as it is vital that the lettering should look as professional as possible.

The finished artwork
Finish off by using the sable brush to sharpen the lines and define the sharp edges and highlights. Fix the picture using a gum arabic solution.

Understanding textures/1

This project will familiarize you with painting different textures – the matt eggshell, the dull ceramic texture of the egg-cup, and the glossiness of the yolk. Pay particular attention to shadows and highlights; using these carefully makes the rendering of most surface textures extremely realistic.

On a highly reflective smooth surface, shadows and highlights will be hard edged and well defined, as the surface will reflect the objects causing the shadow clearly, as well as reflecting the light source itself. Rougher surfaces, on the other hand, will blur any highlights and shadows, giving them soft and undefined edges. If you plan your rendering carefully, you will be able to enhance the textures still further through careful addition of detail. In this case, the characteristic mottling on the egg shell is the obvious example.

When depicting an object as familiar as an egg in an egg-cup, it is important not to show it from a conventional viewpoint. Look at the subject matter from as creative a point of view as possible – here, for instance, I emphasized the yolk trickling down the side of the egg, and on to the table.

1 Trace the drawing on to the line board using the grid method *(see pp24-5)*. Lay masking film over the shell areas and spray them in a base colour of Naples yellow. Choose the direction of the light source, then create the contours with subtle shading, building up the density of colour as you work. ▷

2 Continue building up tone and shadows, paying particular attention to the contact area of the egg and cup, where a shadow would occur. ▽

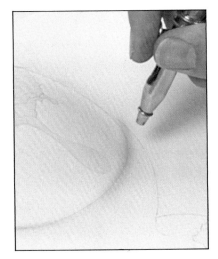

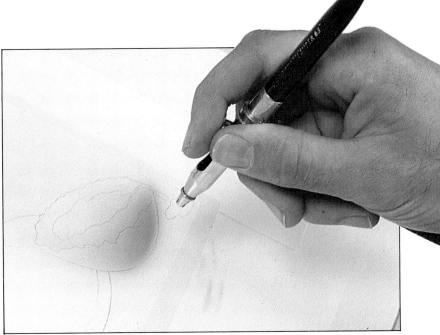

3 Using a darker tint, such as raw sienna, continue building up tone until you are happy with the result.

Remember that eggs vary a great deal in colour, so the 'correct' colour is very much a matter of personal choice.

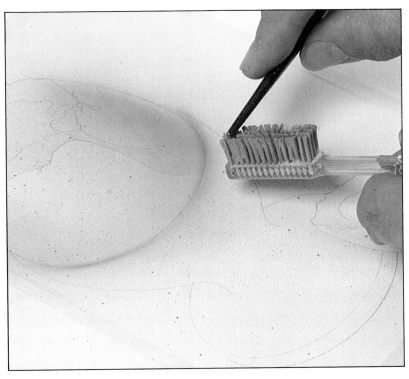

4 Now you must render the random mottled texture of the eggshell. To do this, dab an old, clean toothbrush into a palette of watercolour and draw a stiff object over the bristles toward you to create a spatter effect. This is an accepted technique but one that is difficult to control, so practise on a sheet of scrap paper before working on the artwork. To avoid disasters, do not load the toothbrush with too much paint, and work up the mottling gradually. I used separate applications of burnt umber and white to create the right effect. ▷

Understanding textures/2

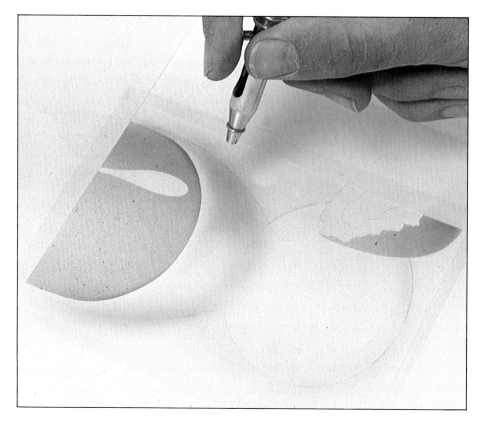

5 Although the egg-cup has a simple shape, it will need careful planning if you are to achieve a convincing effect. You may find it useful to make a rough sketch of light against shade first. Then, mask off the egg-cup and begin to build up the tones gradually, using ultramarine. ▷

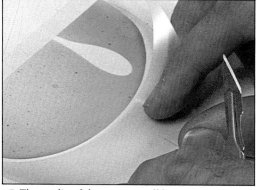

6 The top lip of the egg-cup will have a natural shadow. Take the mask of the cup that you cut out in **5**, and reposition it so that it sits slightly lower.

7 Spray the shadow, keeping the airbrush relatively close to the board. Use the same colour as before but create the shadow by building up the density of the spraying. Remember that the edge of the shadow will not be sharp, so soften the image by moving the mask up and down slightly during spraying. ▷

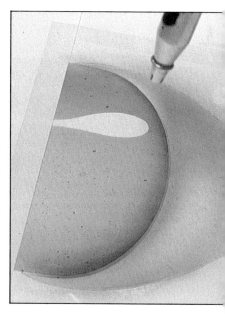

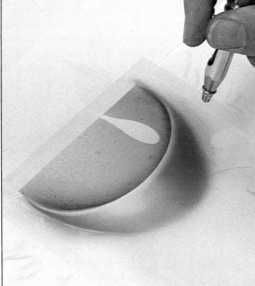

8 Continue to build up the bowl of the cup by increasing the intensity of the blue, taking care to keep enough contrast to the highlight on the rim of the cup. ▷

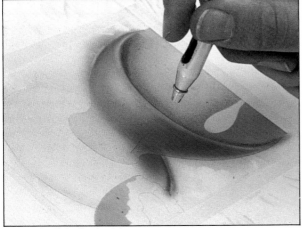

9 Mask off the back of the base of the egg-cup, and cut an elliptical edge to the base of the stem. This will give a hard edge against which you can develop the shading on the base.

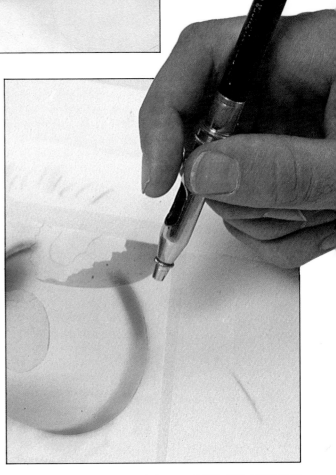

10 Continue to build up the tones on the front edge of the base of the egg-cup. Take care to build up the tones gradually – remember that it is much easier to add than it is to remove paint. ▷

Understanding textures/3

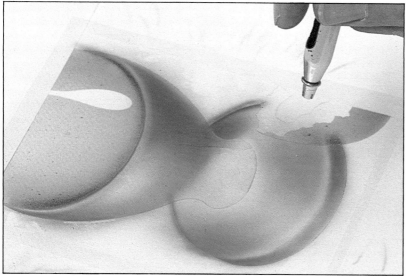

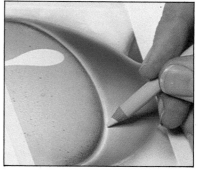

11 As you build up the tones on the base, take care to retain the soft highlight along the front edge of the egg-cup through careful spraying.

12 Having completed the build-up of blue tones on the cup, now concentrate on the highlights. Instead of using the airbrush to apply highlights of white gouache, it is quite acceptable to use a hard pencil rubber to erase the existing colour and thereby create a highlight. This method tends to damage the surface of the board, so only do it when you are sure that you have finished airbrushing that area.

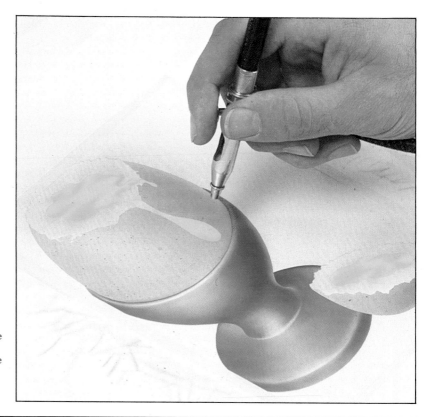

13 Mask off all the portions of yolk. Using cadmium yellow, spray the subtle contours of the yolk. When showing the yolk running down the side of the shell, remember that because it is liquid, you can show its opacity by hinting at the eggshell underneath it. ▷

14 Build up the teardrop look of the dripping yolk by adding deeper tones of cadmium yellow and orange lake to create the form.

15 Leave the egg white unpainted, with the white of the board showing through. Show the texture of the cooked egg white by painting in shadows, using a hint of Davy's grey. ▷

The finished artwork
When you have finished spraying, add the finishing touches with a fine sable brush and gouache. Remember that you are just touching up the picture and adding contrast where it is required – do not line in the image. Fix the illustration by spraying it with an equal mixture of water and gum arabic. When you have finished, clean your airbrush thoroughly.

Working with textures/1

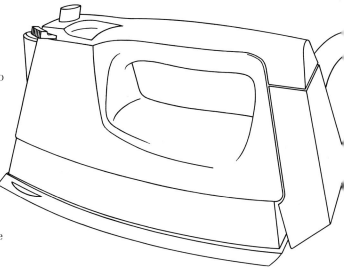

Depicting an iron is a good exercise in working with different surface textures – in this case, chrome, plastic and aluminium. It provides an opportunity to practise finishing brushwork for areas such as the flex, and the joins in the plastic body and handle area.

Because the body consists of a series of compound curves, it requires careful planning of light and shade to produce a convincing result. You will find it helpful to use photographic reference or a real iron. In this example I have applied simple reflections, but you can create more adventurous ones if you feel confident.

Remember the lining-in stage is crucial. This is especially the case here, since the joins of the plastic must give extra definition to the existing curves of the handle. If they are painted badly, they will spoil the look of the whole illustration. For this reason, it is a good idea to practise lining on some spare board until you are confident of the result. Try lining on a surface that has been sprayed as well, as the paint can affect the quality of the line. If you do not feel sufficiently confident to use a brush, a ruling pen can be used in combination with a ruler or French curves.

Paint consistency is also important. It must be thin enough to allow a free flow from the brush.

2 Build up the shadows. Cut a small piece of film to the shape of the contours at the rear of the handle. Spray a deeper tone to define the rear inside edge of the body and the shadow cast by the handle. Take care that no extraneous paint spreads too far down the mask.

1 Transfer the line drawing of the iron on to a piece of tracing paper, using the grid method (*see pp24-5*), then trace this on to the cleaned board. Mask off the complete body area of the iron and apply the first basic tones of light grey.

3 Using freehand spraying, build up the tone beneath the handle so that you show its compound curves. Remember that on a curved surface, a certain amount of light is reflected from any adjacent surface, so that the darkest area of shadow will lie slightly above the edge of the object. Continue building this tone on the top edge of the handle. Move the artwork as you work to give yourself maximum control when spraying the sweep of shadow. ▷

4 Using two overlapping loose paper masks, build up tone to define the sharp corner at the front of the body of the iron. Work as close as possible to the artwork without allowing the spray to spread down the mask.

5 Mask off the rear portion of the iron, using a separate piece of adhesive masking film. Spray from that edge, lightening the tone as you progress towards the rear. Remember that it is the interplay of light and shade which creates the three-dimensional image. ▷

Working with textures/2

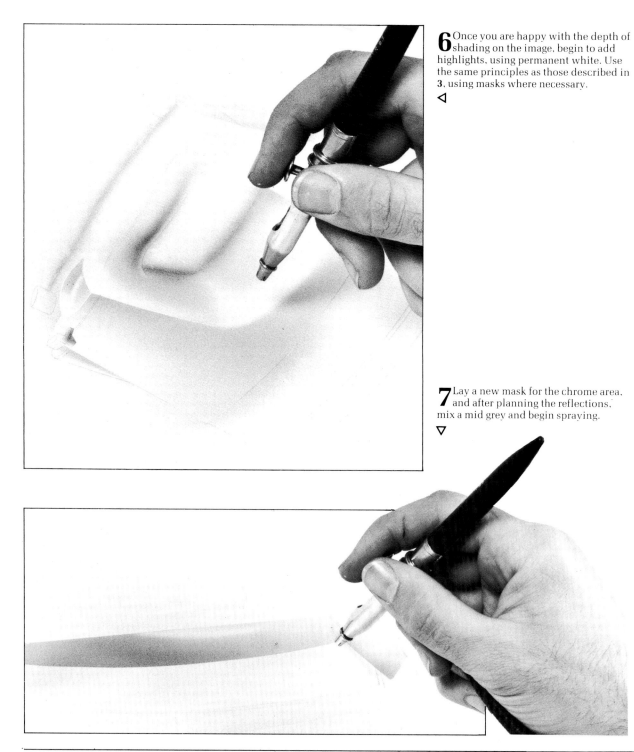

6 Once you are happy with the depth of shading on the image, begin to add highlights, using permanent white. Use the same principles as those described in **3**, using masks where necessary. ◁

7 Lay a new mask for the chrome area, and after planning the reflections, mix a mid grey and begin spraying. ▽

8 Using a loose paper mask, spray away from the edge. This time, use darker tones, such as charcoal grey. ▽

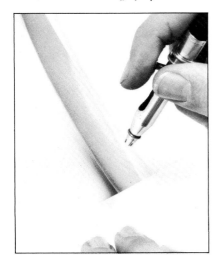

9 Using the same charcoal grey, continue building up the reflections, using cut paper masks for the contours. Make frequent checks to ensure you are achieving a good balance of shadow.

◁

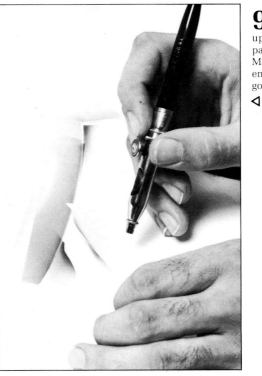

10 At a later stage, you will position a cloth underneath the iron to give added interest to the picture. If you were making a colour rendering, you would use the natural reflectivity of the chrome to show the colour of the cloth in order to integrate the iron with the cloth. Now cut out the mask for the aluminium base of the iron. As aluminium is not highly reflective, you need only spray a simple graded tone running from front to back. Use a tint of mid grey. ▷

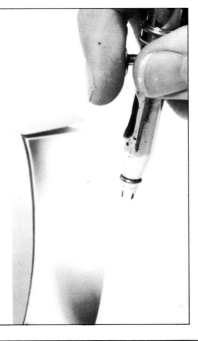

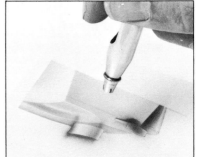

11 Mask the areas around the control buttons. Apply an initial base tone of mid grey over all the button areas. Replace the mask and carefully cut out the cylindrical areas of the buttons. Even in such small areas as this you must follow the principles given for working on cylinders (see pp38-9). Once you have sprayed the shadows, replace the masks. Now remove the top portions of the masks and spray a graded tone from the rear to the front of the buttons.

Working with textures/3

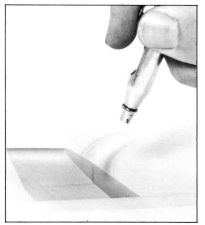

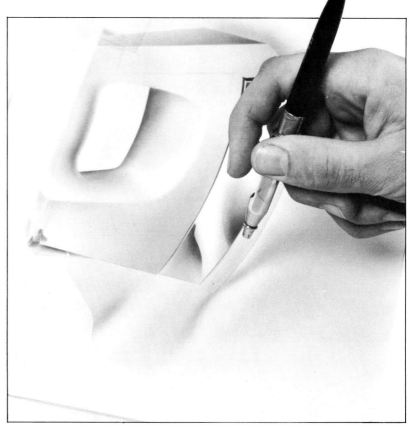

12 Cut a mask around the plastic flex protector area and, using light grey, build up tones to represent a cylinder (*see pp38-9*). As the protector is made of off-white plastic, this single application of tone is sufficient. Replace the cut-out of the plastic covering and mask off the rest of the flex area. Apply a basic tone in the same shade of grey as that used in the previous stage. This one application is enough as the braiding will be hand-painted.

13 Mask off the complete iron, the ▽ edge of the cloth and the outer area of the picture. Spray a base tone for the cloth, then spray the soft shadows created by the iron and the folds of the material. Continue to build up the contours of the cloth. Take care not to overpower the image of the iron, which is the main object of interest.

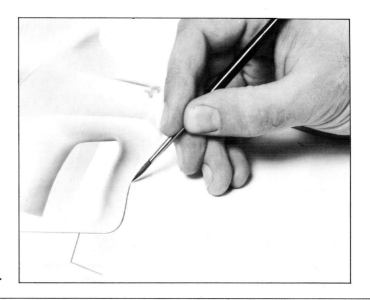

14 Choose a shade slightly darker than the deepest shade of the plastic section you have already sprayed and paint it in using a fine sable brush. ▷

15 To paint the straight lines, use a ruler to guide your hand, inclining it at an angle of 45° to the board. Run the metal part of the brush along the straight edge.

◁

The finished artwork
Continue lining in where you feel it necessary to sharpen the overall drawing, and add further highlights where appropriate. Fix the illustration by spraying it with an equal mixture of gum arabic and water, remembering to clean the airbrush thoroughly afterwards.

16 You must paint the patterns of the braided flex by hand. Study the patterns on the actual iron, or photograph first, then try simplifying what you see to give a convincing impression rather than an exact reproduction of the complex patterns of the material.

Accurate reproduction/1

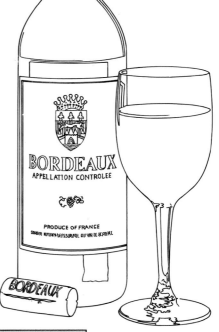

This is an exercise in accurately reproducing a wine bottle and glass, working to an imagined brief, as you would do if the illustration were intended for publication. As a result of this, you must take into consideration the means of reproduction, the colours and the positioning of the image in the illustration. Creating the look of clear glass requires considerable planning when breaking down the various abstract shapes and colours.

Normally, when working for advertising, you would have to adhere to an agreed format, which will have been worked out by the client in advance. In this case, you have more flexibility, but nevertheless, the colours and overall impression must be convincing. Work in watercolours, as these will ensure that the finished illustration is as bright and attractive in colour as possible, and lay the deepest tones first, working from the shadow areas to the highlights.

When you paint a three-dimensional glass object, such as a bottle or glass, you ignore the shadows cast on the front of the glass. Instead, paint what you see when looking through the glass, and build colour over that to create the three-dimensional effect.

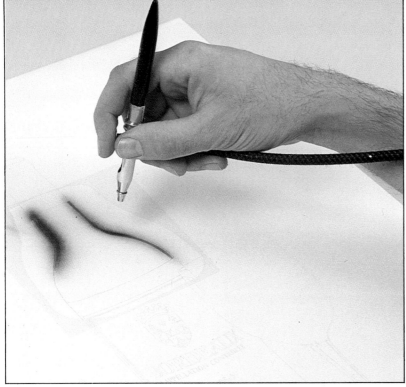

1 Enlarge the line drawing to a convenient size, using the grid method (see pp24-5). In this case, I enlarged the drawing to a height of 15in (37.5cm). Accurately trace through the transfer sheet the contours of the objects and the reflections. Then cover the whole line board with tracing paper or detail paper, and cut out the dark shadow areas towards the edges of the bottle. Mix Windsor green with Prussian blue to give added depth. Spray the shadows, deepening the areas closest to the neck. Continue to build on the shadow areas, mixing more blue into the original colour as the shadows deepen. ◁

2 Cut out the rest of the top portion of the bottle, while leaving areas of strong highlight masked off. Using a mixture of leaf green and Windsor green as the basic colour, begin spraying the contours of the back of the bottle. ▷

3 Using the mix of dark green and Prussian blue, build up the shadows. Don't worry too much at this stage about the overall effect – try instead to include some interesting shadow details. When you are satisfied with the shadows, remove the masked-off highlight sections. ▷

4 Now begin work on the front of the bottle. Using the same shade of dark green, begin overspraying the front contours, while allowing the base to show through. ▷

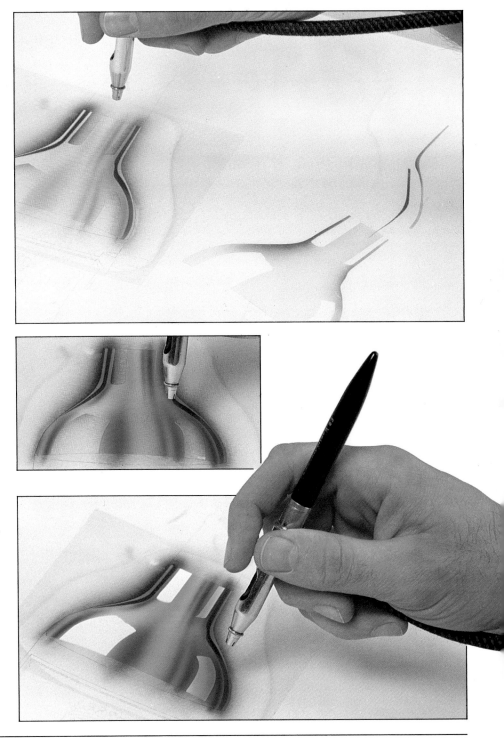

Accurate reproduction/2

5 Cut masks for the darker areas at the extreme tip of the bottle, and spray them in base green. The outer edges should be sprayed fairly darkly to define the top, as well as the shadows, which should correspond to the one on the neck. Spray a lighter green across the front, fading it away and leaving a highlight along the top edge.

6 Cut a new mask for the wine-filled part of the bottle, then cut out the deepest shadow areas. Mix a suitable colour, remembering that although the wine is red, it is being viewed through green glass, so it will be a different colour from normal. A mix of magenta and spectrum red gives a good effect. Spray the area, intensifying the colour towards the shadowed edge.

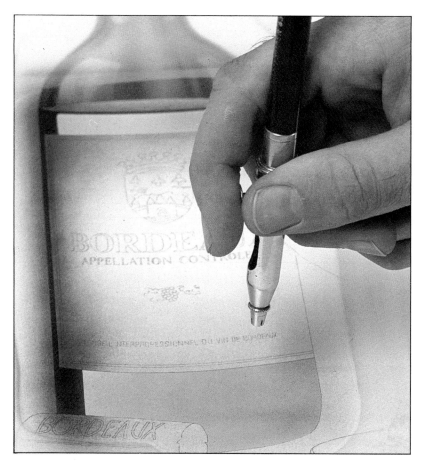

7 Remove the masks covering the rest of the wine areas, but leave the surface of the wine masked. Spray a base tint of red, building up the tones to create an impression of being able to see the base of the bottle. ▷

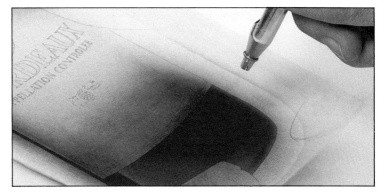

8 Darken the red by mixing it with magenta, and build up the tones further. It is important to build the colours gradually to suggest the transparency of the wine. This will show through in the final image. ▷

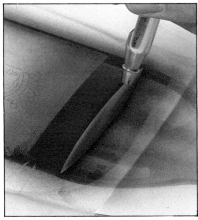

9 Mask off the surface of the wine and spray it with dark magenta. Remember that the wine has surface tension which must show through the glass, and that it also has a meniscus.

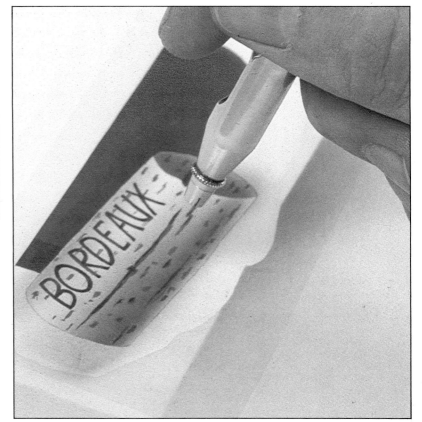

10 When working on the cork, paint the lettering first, using a fine sable brush and brown watercolour. Once the lettering has dried, paint the cork to show its irregular texture and markings. To do this, mix up slightly different tones of brown to give variety to the markings. Then mask off the end portion of the cork, and using a mixture of Vandyke brown, spectrum red and cadmium yellow, spray the shaded area. Remove the rest of the masking to the cork, and build up the shadow, using the cylinder principle (see pp38-9).

Accurate reproduction/3

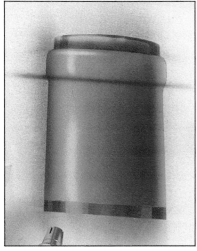

11 Cut out a mask for the metal cap at the top of the wine bottle. Spray it with a basic tone in cadmium red. This portion is less reflective, requiring less detailed work in the spraying. Then, resting the airbrush against a metal rule to act as a guide, spray the shadow on the underside of the lip of the bottle. Deepen the shading using neutral tint and add highlights in permanent white.

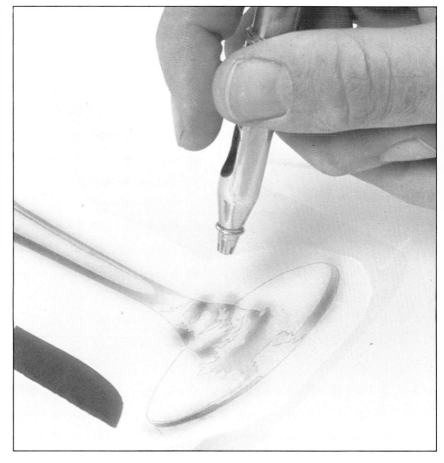

12 To paint the wine ▽ glass, draw the reflected areas in line on to the illustration, then mask off the whole stem and cut out those areas that will be darkest. Spray these shadow areas using a thin mix of jet black, deepening the density where applicable. Then cut out the remaining glass section, leaving only the area which is to be solid white. Mix a thin tone of Payne's grey, and spray to give some colour to the glass. The wine in the glass will cast reflections on the stem and base, so carefully paint these in freehand, using vermillion. This is the same colour that you will use for the wine in the bowl of the glass. Remember that the wine in the glass will be a different shade from that in the bottle, which is viewed through green glass. ▷

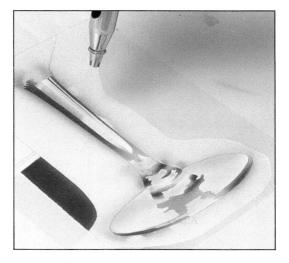

13 The meniscus in the wine glass is the darkest area of colour. Mask this off and cut out the area, then spray on a graduated tone of vermillion. ▽

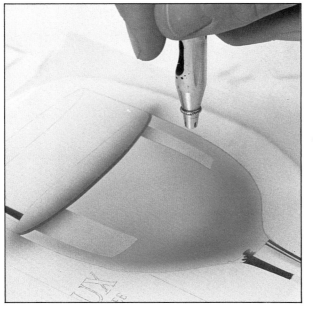

14 Using the same mask, cut out the bowl section, leaving the highlighted areas masked off as in the top section of the bottle. Spray with vermillion, and build up the shape of the wine-filled bowl, taking care to allow enough of the white base to show through. ◁

15 Using a scalpel, carefully remove the masks which have covered the highlighted areas.

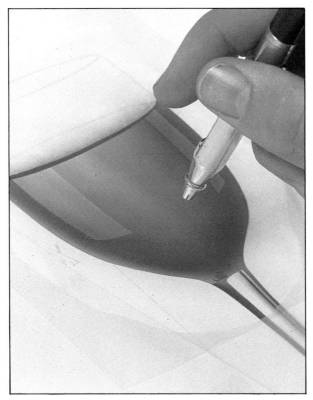

16 Now intensify the vermillion by mixing it with crimson. Then spray the highlighted areas and deepen the shadows. ◁

Accurate reproduction/4

17 Cut out the remaining portion of the mask which covered the surface area of the wine. Using close, careful, freehand spraying, build up the texture of the surface. ▷

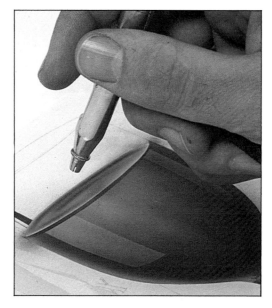

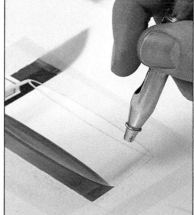

18 Using a fresh mask, cut out the shape of the back of the glass. Spray the delicate tones of the glass with the same thin tone of Payne's grey as you used in the stem. As a portion of the label will be seen through the top of the wine glass, now is a good time to paint in the gold outline around the label, using a ruler as a guide. Then line in the gold design at the centre of the label. Do this freehand, with a fine sable brush and a mix of raw umber and cadmium yellow.

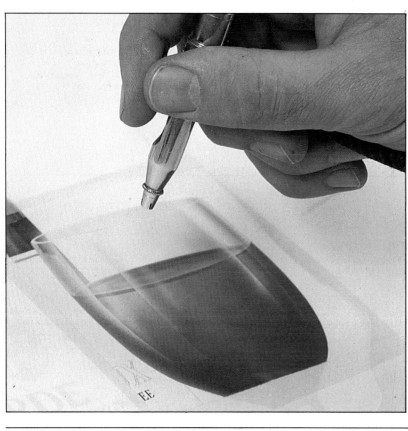

19 To give definition to the front portion of the glass you must now cut and mask the front area. Overspray it with a thinned neutral tint to create the shadow areas, then use permanent white to bring out the highlights. ◁

20 Now begin work on the wine label. It is extremely important that you paint in hand lettering as professionally and carefully as possible, since a poor attempt will completely spoil the appearance of the illustration. If you lack confidence in your ability to achieve a good result with hand lettering, choose a simple image that can be rendered effectively as areas of tone.

Before beginning to paint in the lettering on the artwork, practise first on some scrap paper or a spare line board until you are completely confident and ready to begin work on the real illustration. Use lamp black and a fine sable brush, and begin to paint in the lettering. Use a ruler to help you when painting straight lines, and work the curves freehand. Once the lettering is completed, and has dried, mask off the whole label area and spray it with a delicate grey tint to suggest the curved shape of the bottle, following the light source. To integrate the wine glass with the wine bottle, spray a hint of vermillion over the label to give a hint of reflected colour.

Touch up the lining in where necessary, and then fix the illustration in the usual way, using a solution of equal amounts of water and gum arabic. ▷

The finished artwork
A picture of the finished illustration is shown on the following page.

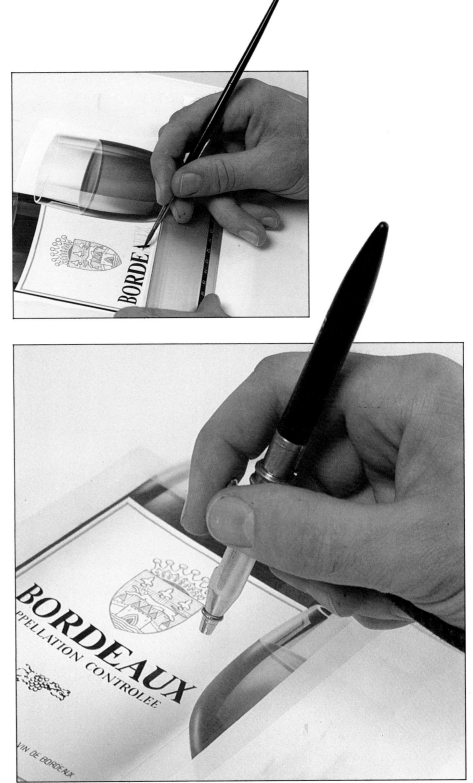

The finished artwork
It is especially important to apply the correct finishing touches to a piece of artwork intended for publication, because any blemishes or omissions will be obvious when it is printed. Check that the hand lettering is complete, with no untidy lines, and the shades of colour are consistent.

BORDEAUX

APPELLATION CONTROLEE

CONSEIL INTERPROFESSIONNEL DU VIN DE BORDEAUX

BORDEAUX

Advanced airbrushing

Airbrush artists have been commissioned by advertising agencies, design studios and publishers for many years to produce images for the printed page. These range from illustrations with an almost uncanny photographic quality to stylistic designs that can only be achieved with an airbrush. The following pages contain examples of many illustrative styles, to show you the versatility and professionalism of the airbrush.

Advanced airbrushing 92

Dick Ward

Knickers

25 x 18in (62.5 x 45cm)

Gouache

An accomplished artist can produce a
tremendous variety of effects with an
airbrush, from fine details to broad
sweeps of colour. For example, Dick
Ward worked the sand in this
illustration by fitting a spatter cap to his
airbrush. To work the shadowed areas of
the sand, he sprayed them with strongly
diluted gouache. This gave the required
deep shadow tone without obscuring the
grainy texture of the sand he had already
worked. Throughout the illustration,
Dick Ward used a combination of hard
and soft masking, the latter with French
curves, and applied the finishing
touches with a fine sable paintbrush.

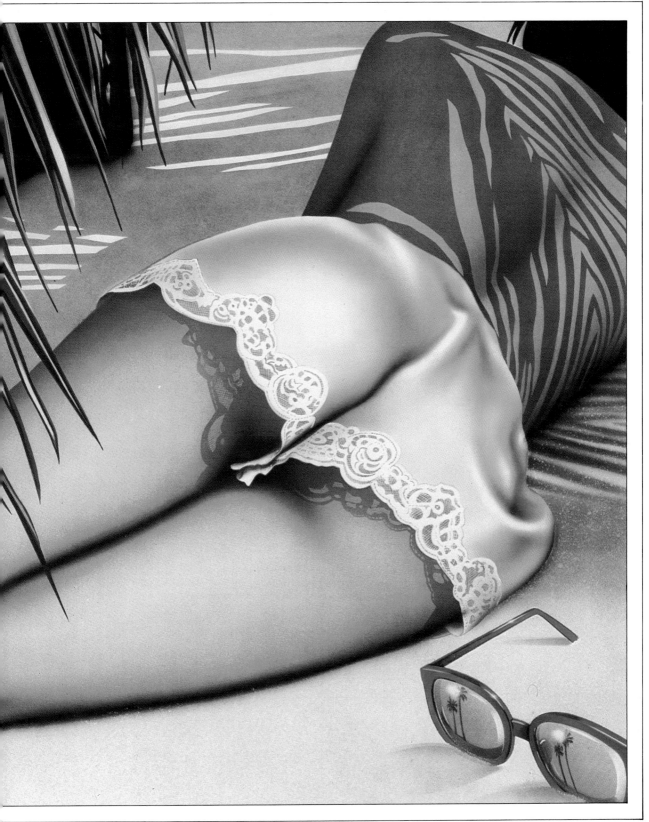

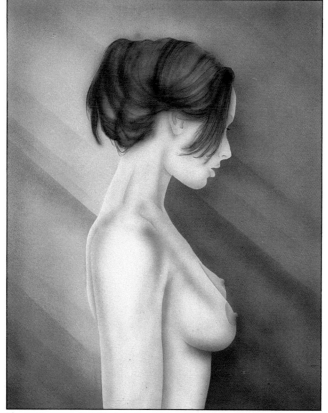

Roger Pearse – Untitled nude – 13 x 16in (32.5 x 40cm) – Ink

Professional airbrush artists often develop individual techniques that are peculiar to themselves. Roger Pearse, who created this illustration for an exhibition of his work, found that paper masks would not be soft and subtle enough for the gentle shading on the figure, so he used his fingers and thumbs as soft masks instead. He has also devised an unusual way of spraying soft tones like these – having set his compressor to give low air pressure, he removes the back of his airbrush, unscrews the needle locking nut and then sprays with his right hand while moving the fluid needle backwards and forwards with his left.

Pete Brannon

Japanese lady

20 x 30in (50 x 75cm)

Gouache

The finishing touches to an illustration are often applied with a fine sable paintbrush, but this need not always be the case. Here, Pete Brannon used coloured pencil crayons to add definition in the final stages of this painting. After transferring the original line drawing to the line board with a transfer sheet, the artist performed the spraying in gouache.

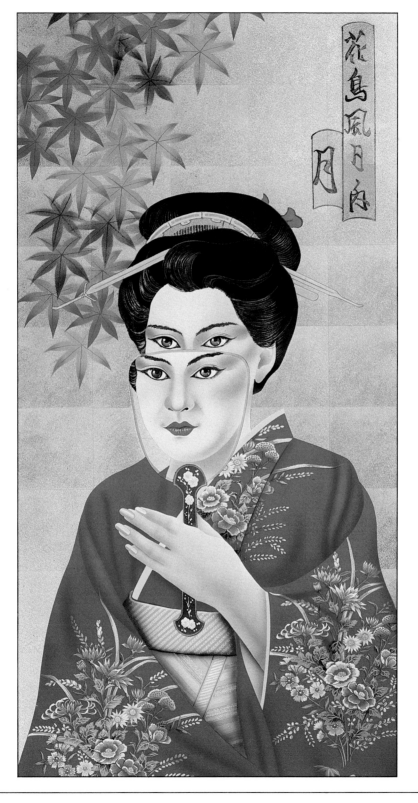

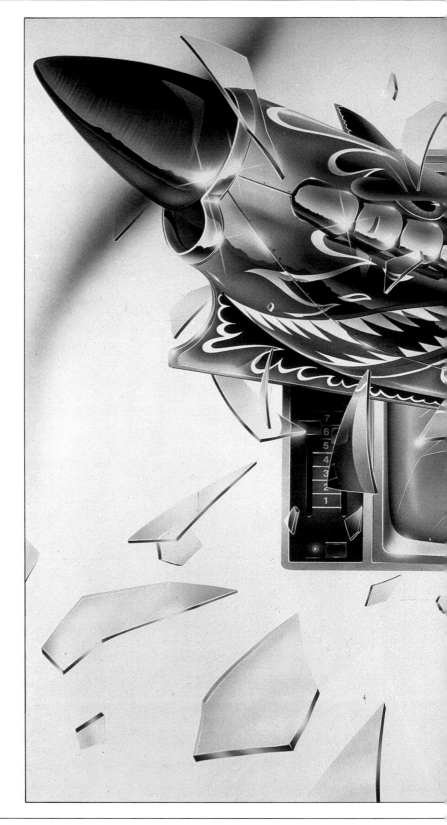

Tom Stimpson

Untitled illustration of an aeroplane
and television

30 x 40in (75 x 100cm)

Ink

When Tom Stimpson began this
illustration, working with solid colour
was a new experience for him. He used
ink because he wanted to give the
artwork a vibrant colour and a sense of
impact. The final details were applied
with a fine sable paintbrush.

Melvyn Bagshaw – The Green Angel – 17¼ x 23½in (43 x 58.75cm) – Gouache and ink

The versatility of the airbrush means that an artist can work with a mixture of media, such as the gouache and ink used in this illustration. It was devised for a competition to produce a design for a cocktail entitled *The Green Angel*. Melvyn Bagshaw worked on CS10 line board, using black ink as a base. He then built up the image by airbrushing with gouache.

Tom Stimpson – Untitled illustration of a man's brain – 16¾ x 23½in (42 x 59.5cm) – Watercolour

The success of this illustration relied on the amount of detailed work that was added once the basic tones had been sprayed freehand in watercolour. Tom Stimpson used a fine sable paintbrush and a ruling pen to apply the details and lines around the brain.

Tom Stimpson

Untitled illustration of a tower block
and lorry

18 x 18in (45 x 45cm)

Gouache

The airbrush is especially effective
when the artist wants a photo-realistic
image, as Tom Stimpson did here. He
used hard masks and completed the
illustration by adding the final details
with a fine sable paintbrush.

Pete Brannon

Untitled illustrations of a car

20 x 30in (50 x 75cm)

Gouache

Commissioned illustrations of cars have to be as accurate as possible, with the artist usually working from photographic reference supplied by the client. These two pieces of artwork were commissioned for a small poster advertising cars. Each technically accurate image was drawn in ink on to the boards, and the illustrations were then sprayed with gouache, and finished with a small amount of fine brushwork in gouache.

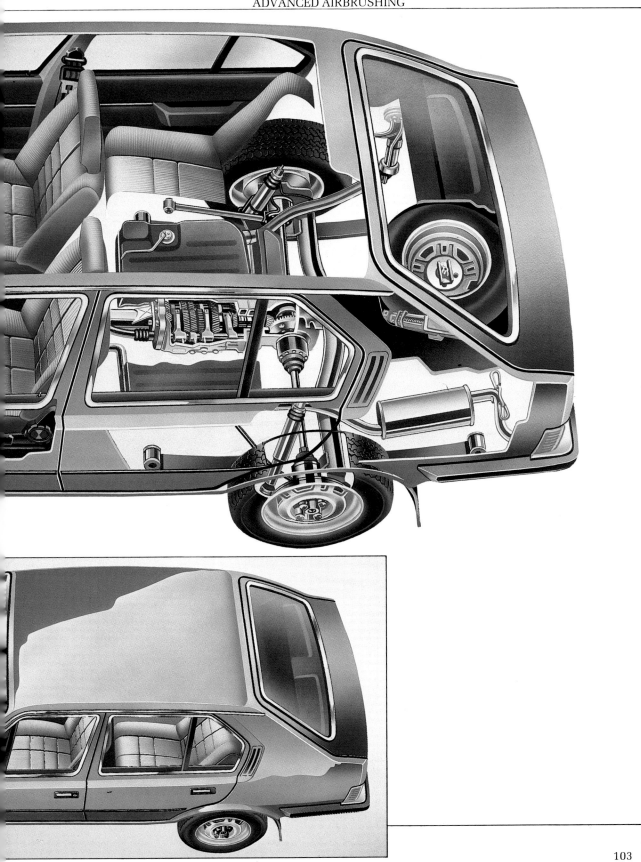

Street Machine – Cellulose paint

The even tones and smooth finish achieved by the airbrush make it ideal for car-customizing. The surface of the car is treated in the same way as a board or paper, once a base colour has been applied. Then, the chosen image is transferred to the surface with tracing down paper, and the artist then begins to spray, using cellulose paint and loose masking. Once the illustration is completed, it is normal to apply as many as fifteen coats of lacquer as protection from damage. Here, all the potential of the airbrush has been utilized to produce a classic view of a Citroen 2CV for the magazine *Street Machine*.

Tom Liddell

Untitled illustration of a
traction engine

18½ x 33in (46.25 x 82.5cm)

Gouache

An airbrush is an ideal
instrument when working on
very detailed pieces of
artwork, because it offers the
artist a high degree of control.
This illustration of an
Allchin traction engine was
intended to be the first of a
series of six posters. The
detailed drawing, for which
technical drawings of the
engine were used as
reference, was transferred to
CS10 line board with rouge
paper and a steel point. Once
the spraying was completed,
Tom Liddell finished the
illustration with brushwork,
and applied the highlights on
every edge with a fine
paintbrush and gouache.

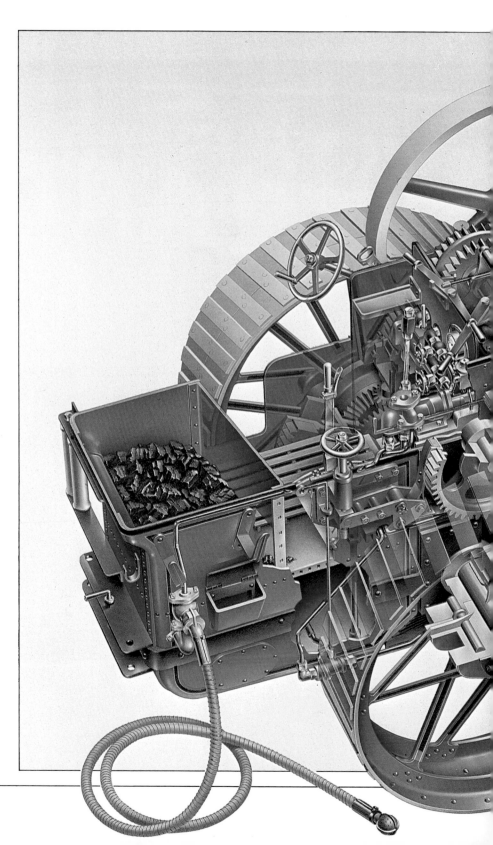

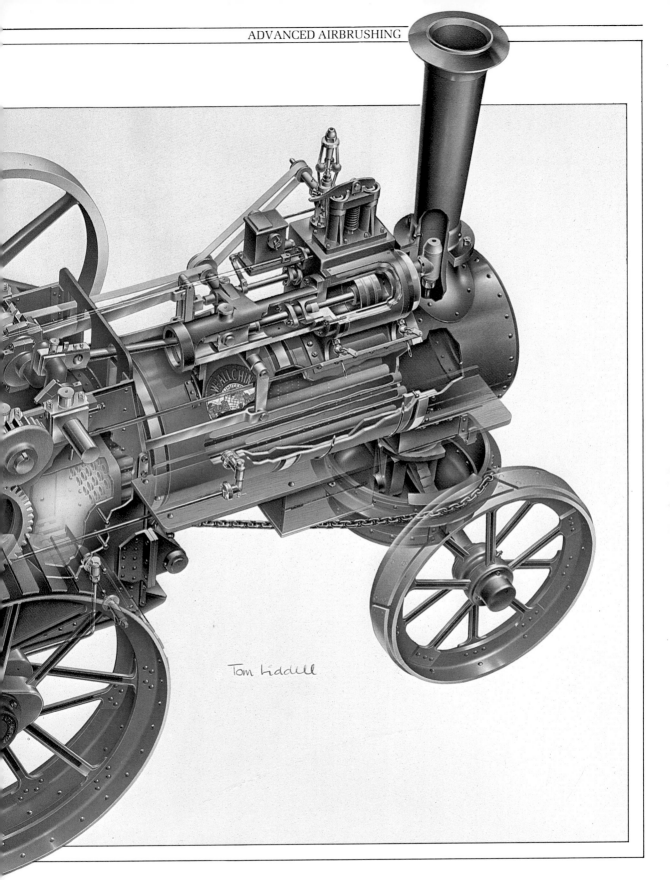

Tom Liddell

Tom Liddell

Untitled cutaway illustration for Case Tractors

18½ x 33in (46.25 x 82.5cm)

Gouache and watercolour

The airbrush is particularly suitable for 'ghosted' work – illustrations, often technical, in which many components appear transparent. These ghosted areas are oversprayed in watercolour, which gives the correct translucent effect without obliterating the underlying paintwork. In this case, after spraying the base tones with gouache, Tom Liddell sprayed the ghosted areas of the illustration with watercolour, then added the finishing touches with fine brushwork. This illustration was published as a poster advertising David Brown Tractors, now Case Tractors.

Jim Bamber

Untitled illustration of Audi

26½ x 17⅛in (66 x 43cm)

Gouache and watercolour

Jim Bamber photographed one dismantled Audi and one complete car to obtain his reference for this illustration. After spraying, he added the details and hand lettering with a brush.

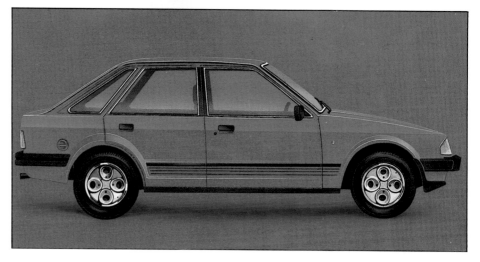

Industrial Art Studio

Untitled illustration of Ford Escort

18 x 12in (45 x 30cm)

Gouache

Illustrations are not always sprayed separately. Here, the car was built out of the background colour. First, an overall red tone was sprayed then, after building up the form of the car and working on the wheels, the body panels were defined by showing their areas of light and shade.

Grose Thurston

Untitled illustration of a Rolls-Royce

14 x 12in (35 x 30cm)

Gouache

The amount of airbrush work in an illustration will be determined to a great extent by the nature of the image. In this example large areas of the artwork were airbrushed, and only the details, such as the reflections in the chrome, were applied with a fine sable paintbrush. Other illustrations, however, call for more brushwork. ▷

Tom Stimpson – Untitled illustration of a helicopter and truck – 18 x 18in (45 x 45cm) – Gouache

The choice of medium that Tom Stimpson could use in this illustration was dictated by the amount of hand-painting that the trees, mountains and figures required. The truck was sprayed in gouache with a flat army green, then the black details were added. To obtain the highlights, areas of gouache were scratched away with a scalpel blade – Tom Stimpson feels this gives a more effective highlight when the artwork is going to be printed in a reduced size.

Ian Naylor

Into the music

21 x 31in (52.5 x 47.5cm)

Gouache and ink

Literally a flight of fantasy, this artwork shows the smooth effect an airbrush can produce. This artwork was created by Ian Naylor as a piece of self-promotion, working with gouache and ink on CS10 line board. As well as hard masking, he used a considerable amount of loose card masks and finished the illustration with fine freehand brushwork.

Pete Brannon – Untitled illustration of a duvet in space – 20 x 30in (50 x 75cm) – Gouache

The soft nature of this artwork meant that Pete Brannon had to choose his masking very carefully. To achieve the fine edges of the clouds, he used masks made from pieces of ripped tissue paper. As normal low-tack adhesive masking film would have given too hard an edge to the duvet, he used acetate instead for a more gentle, diffused, effect.

Keith Noble – Untitled illustration for poster – 20 x 14in (50 x 35cm) Watercolour

While an airbrush can be used to produce a stylized effect, it can also give the
opposite effect of photo-realism, as in this artwork for a poster advertising the
film *Diva*. Keith Noble used a 16mm still from the film as reference. The image
was drawn on to CS10 line board in pencil, and the illustration was sprayed in
watercolour. Areas of watercolour were then rubbed out with a hard rubber to
obtain fluorescent, scratchy, highlights. The masks were cut out of cartridge
paper and taped on to the board. The artist then lifted the edges of the masks to
keep the sprayed edges of the image soft.

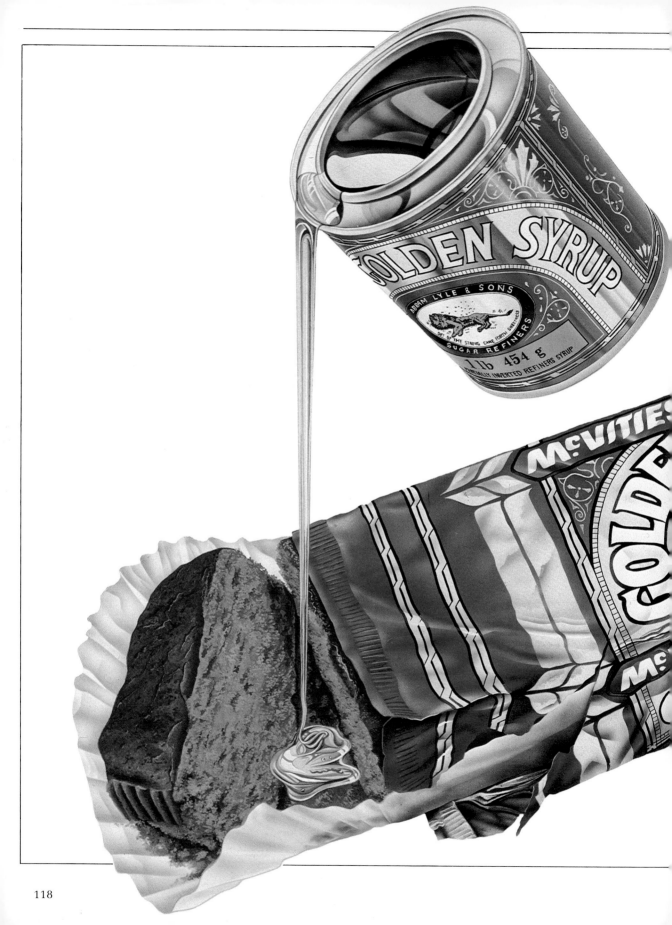

Industrial Art Studio

Untitled illustration of
Golden Syrup tin and cake

14 x 10in (35 x 25cm)

Gouache

One of the advantages of
airbrushing is that it
can represent certain objects
better than any other
medium. It would have been
both expensive and difficult
to photograph an image such
as this, because of the
position of the tin, the need
for it to be as perfect as
possible, and the heavy
texture of the syrup, which
would have to pour in a
steady stream without
forming any bubbles. These
are minor considerations for
an airbrush artist. The
problem, however, is posed
by the exacting detail and
complete accuracy required.
The artist therefore applied
the basic tones and
background colours with an
airbrush, and then worked,
with a fine sable paintbrush,
such details as the hand
lettering and curlicues on the
tin and foil cake packet.

Industrial Art Studio

Untitled illustration of Minolta camera

18 x 12in (45 x 30cm)

Gouache

At first glance it is difficult to determine if this is a
photograph or an illustration, which demonstrates the
extremely realistic effects that can be achieved with an
airbrush. This artwork was produced as self-promotion by
the Industrial Art Studio. In order to secure the greatest
possible degree of accuracy, the artist used a real camera as
reference for a detailed basic drawing, which was then
carefully transferred to CS10 line board using a series of
tracing paper overlays. The photo-realistic effect of this
illustration relies on its accurate detail, so the artist applied
the basic tones with an airbrush, using hard masking. The
many details – for example, the texture of the camera casing
and the lettering – were then rendered with a fine
paintbrush before the finishing touches were applied to the
artwork with the brush itself.

Melvyn Bagshaw

The land of the rising clone

8⅛ x 6¼in (20 x 15.5cm)

Ink

Part of the skill of an airbrush artist lies in selecting the correct medium – or a mixture of media – to achieve the desired effect. Inks, for instance, give a transparency and clarity of colour to artwork, which is why Melvyn Bagshaw chose them for this illustration. He was commissioned by a magazine to illustrate an article on Japanese video piracy, and followed the style of traditional Japanese prints to create an appropriate atmosphere. Melvyn Bagshaw transferred the original line drawing to Schoellershammer paper (a high-quality German paper used by professional artists) with transfer paper, then drew over the outline in ink. He then sprayed the illustration in ink.

Roger Pearse

Anxious Angus

20 x 30in (50 x 75cm)

Gouache and ink

While an airbrush is suitable for precise technical illustrations, it can also be used for animation and cartoons, since it produces such a smooth finish. This cartoon was commissioned for the packaging of a computer game. Roger Pearse sprayed the sky in gouache to create a soft effect, then worked Anxious Angus and the monster in ink, to give a vibrant colour and good contrast with the background. He used a spatter cup on the foreground, and produced the spots on the monster by spraying close to the board, using short sharp bursts of the airbrush. ▷

Nick Farmer – Untitled illustration – 5½ x 8½in (13.75 x 21.25cm) – Gouache and watercolour

Although the rest of this illustration – commissioned for a Ricard brochure – was sprayed in gouache, the shadows were worked in watercolour, to apply a tone without hiding existing details.

Melvyn Bagshaw – D&AD Pencils – 12 x 14in (30 x 35cm) – Gouache and ink

The artist is usually given a very strict brief for commissioned artwork. Here, Melvyn Bagshaw worked from a designer's visual to produce the cover of an entry form and a poster for the 21st Design and Art Direction (D&AD) Awards. The form of the pencils was sprayed in gouache and their sharpened ends worked in ink.

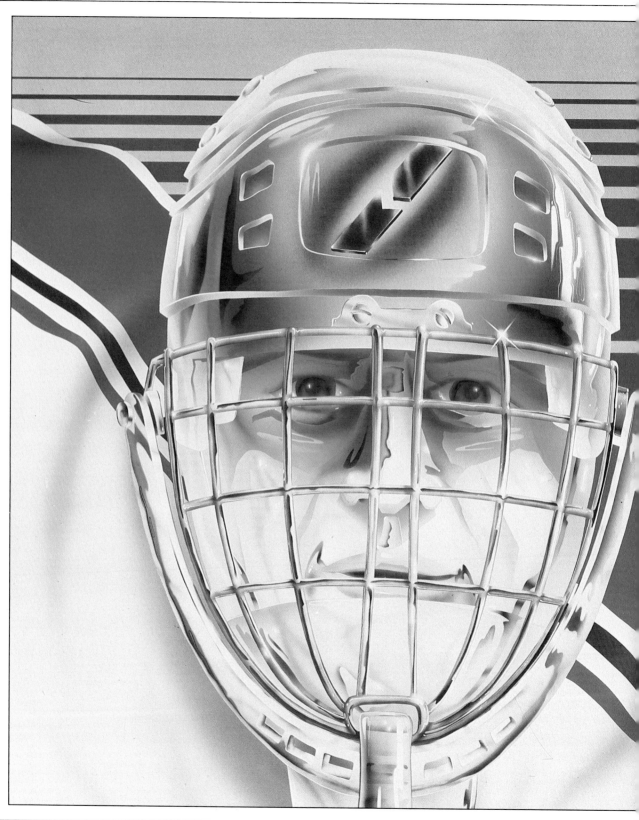

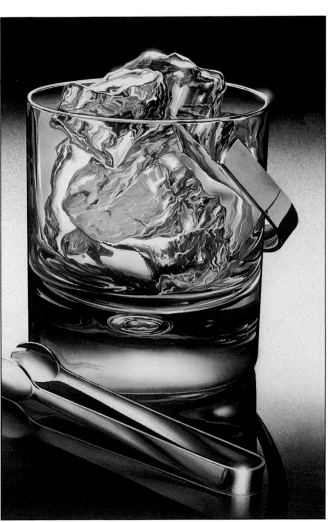

Grose Thurston – Untitled illustration of an ice bucket – 7 x 5in (17.5 x 12.5cm) – Gouache

A selection of photographs were used as the photographic references for this illustration. The artist used hard masking to spray the basic tones, then completed the illustration with fine freehand brushwork.

Nick Farmer

Untitled illustration of an ice hockey player

19½ x 17in (48.75 x 42.5cm)

Gouache and watercolour

◁ Sometimes artists use a combination of media in one illustration, because of the different effects each one gives. Here, it was important that the ice looked as clean and realistic as possible, so Nick Farmer used watercolour for a translucent finish. This illustration was commissioned by the advertising agency Simonson Finnegan to promote Bluecol Antifreeze's sponsorship of the National Ice Hockey Cup. The company colours are shown in the hat.

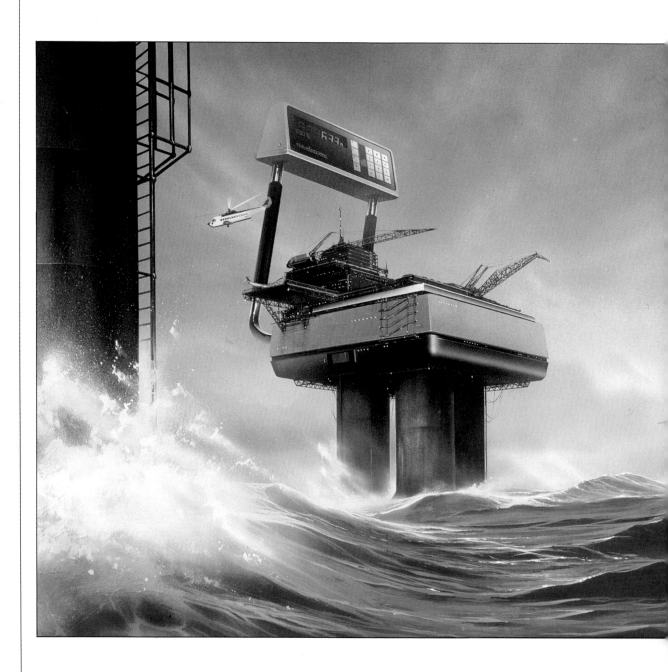

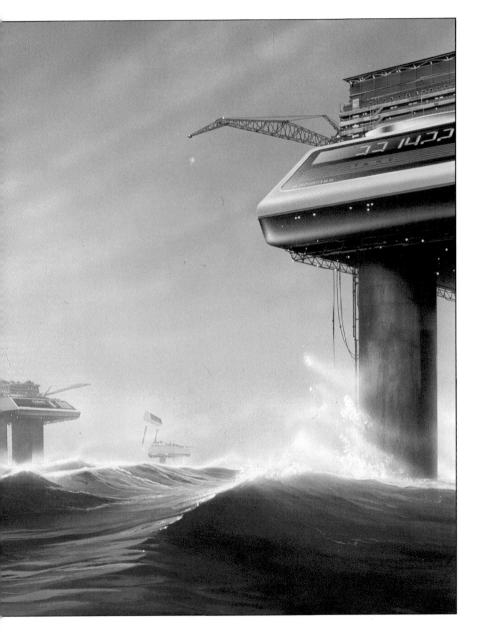

Tom Stimpson

Untitled illustration of
computers

16¾ x 23½in (42 x 59.5cm)

Gouache

An artist usually plans the
order in which an illustration
will be painted before
beginning work. Here, Tom
Stimpson first painted in the
sea, using a paintbrush, and
then filled in the rest of the
picture with an airbrush. He
then had to ensure that the
two halves of the picture
blended together, by adding
final details.

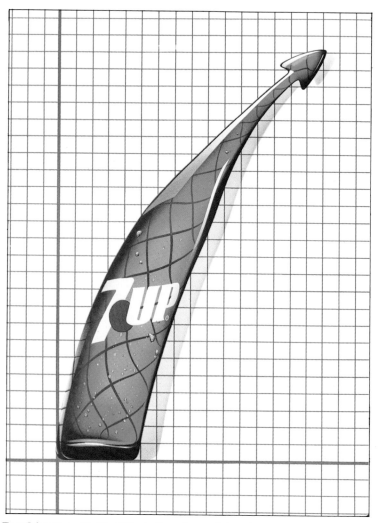

Tom Stimpson – Untitled illustration of a graph for 7 Up – 11½ x 16¾ (29.75 x 42cm) – Gouache

Gouache was an obvious choice for this illustration, because its opacity meant that Tom Stimpson could airbrush one solid colour over another colour that was already on the board. The lines of the graph were drawn in with a ruling pen and gouache, and the hand lettering applied with a fine sable paintbrush.

Tom Stimpson

Untitled illustration advertising Ovaltine

16¾ x 23½in (42 x 59.5cm)

Gouache

This illustration posed two problems for Tom Stimpson. Firstly, the artwork would be printed as a large poster, so the quality of the work had to be consistent – the smallest flaw would be noticeable when the illustration was enlarged. Secondly, but of equal importance, every detail and colour of the Ovaltine packaging had to be exact. After the basic tones were sprayed, Tom Stimpson added the many details with a fine sable paintbrush. ▷

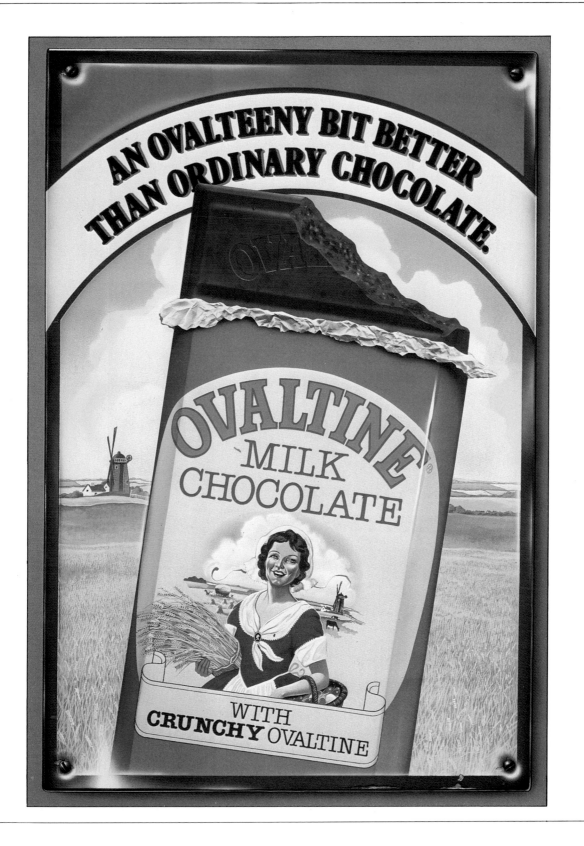

Tom Stimpson – Untitled illustration for a record cover – 20 x 20in (50 x 50cm) – Gouache

Tom Stimpson chose to work on this commissioned artwork in gouache because it would enable him to apply one colour on top of another. He built up the image using hard masks, and applied the hand lettering with a fine sable paintbrush.

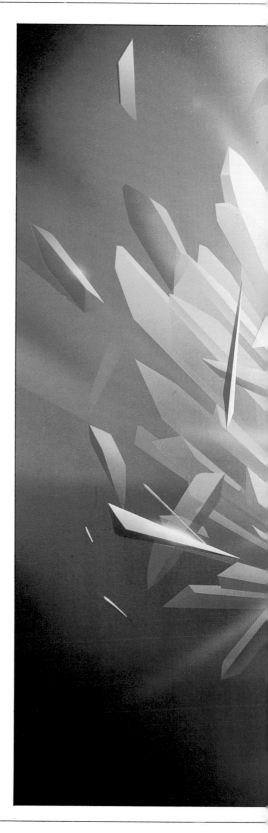

Dick Ward

Communication breakdown

20 x 20in (50 x 50cm)

Gouache

The airbrush comes into its own for illustrations such as this. As well as spraying large areas of even tones, it can also be used for detailed work, such as the bamboo table legs. The artwork was finished with a paintbrush.

Tom Stimpson

Untitled illustration of a nude

8½ x 11½ (210 x 297cm)

Acrylic

This is an unusual illustration in two respects – it is actually in two pieces, and

Tom Stimpson experimented by working on canvas. He discovered that working on such a textured surface meant he was virtually painting with his airbrush. Acrylic is a difficult medium with which to spray, and unless it is regularly flushed away, it can clog the airbrush. To accentuate the painted feel of the work, he went over each area, once it had been sprayed, with a fine sable paintbrush. ▷

Tom Stimpson

Untitled illustration of a computerized dinosaur

15 x 15in (37.5 x 37.5cm)

Ink

The delicate tones and soft gradations of colour required for this artwork meant that ink was the natural choice of medium. Detailed areas, such as the computer cards ranged down the dinosaur's back, were worked by spraying a basic green tone, and then scratching out the details and highlights, using a scalpel blade.

Tom Stimpson

Untitled illustration of sources of energy

18 x 18in (45 x 45cm)

Gouache and ink

Very often, if an artist uses two mediums when working on an illustration, the majority of the work will be performed in one medium, with the other used for small areas. Here, ink was only used for the diesel engine, so that the highlights could be scratched out with a scalpel blade to give a photographic effect. The rest of the illustration was worked in gouache. The sky was sprayed freehand, while the windmill was worked with normal hard and soft masking.

Richard Duckett – Untitled illustration of roller bearings – 20 x 15in (50 x 37.5cm) – Gouache and watercolour

The airbrush is particularly effective when illustrating highly-polished metal finishes, such as that on these steel roller bearings. Richard Duckett was commissioned to produce this artwork for a poster advertising roller bearings, so it was important that they appeared as realistic as possible. He used low-tack adhesive masking throughout and finished the illustration by adding the fine detail with a sable paintbrush.

Dick Ward

Cigarettes

18 x 14in (45 x 35cm)

Gouache

Part of the skill of an artist lies in being able to present an established theme in a new way. Here, Dick Ward wanted to give a different image to the cigarettes, so chose to reflect them in the chrome of the robots. The sharp reflections were created with hard masking, and the final touches were added with a fine brush. ▷

Roger Pearse

Untitled illustration of a flower

18 x 23in (35 x 57.5cm)

Ink

Working with an airbrush is not always confined to hard and soft masking – interesting textures and effects can be produced by freehand spraying, when the airbrush is used like a conventional paintbrush. Here, for example, the petals of the flower were treated in this way, having first masked off their outlines. When planning this illustration, produced for an exhibition of his work, Roger Pearse positioned the flower in such a way that it has a three-dimensional appearance.

Graham Duckett – The Stand – 30 x 20in (75 x 50cm) – Ink and gouache

The vivid, clear colours obtained with inks made them an obvious choice for this artwork. The illustration was commissioned by the pop group The Enid to serve not only as their letterhead, but also as a poster in its own right for their fans, so it had to be striking yet subtle. I used hard masks for the logo, but sprayed the earth freehand. The stars were created with a spatter technique, using a toothbrush. The only part of the illustration to be sprayed in gouache were the highlights, which were worked in white.

Tom Stimpson

Untitled illustration of a space scene

16¾ x 23½ x (42 x 59.5cm)

Ink

The textured surfaces in this illustration appear to belie the smooth finish usually associated with the airbrush. They were achieved by a painstaking method of rubbing off existing patches of ink, scratching these areas with the blade of a scalpel, and then overspraying in ink.

Roger Pearse

Time bomb

20 x 30in (50 x 75cm)

Gouache and ink

Sheets of low-tack masking film are expensive, so
it is advisable to plan the masking procedure
before beginning on the illustration. In this piece
of artwork, commissioned for the packaging of a
computer game, Roger Pearse used only one mask
for the whole background area. He applied
separate coats of gouache to build up the density.
The boot was sprayed in ink, using soft masks.

Rosalind Buckland

Untitled illustration of a bottle of champagne and a cork

11½ x 17½in (28.75 x 43.75cm)

Watercolour

When depicting something as instantaneous as a cork popping out of a bottle of champagne, it is difficult for an artist to work entirely from life. Many artists find the answer to the problem lies in working from accurate photographic reference. Rosalind Buckland created this illustration, on high-quality German Schoellershammer paper, for her portfolio. To produce the bubbles, she masked out the shapes with masking fluid, sprayed watercolour over them, then pulled off the masks with the blade of a scalpel. The cork was worked by first spraying it with watercolour and then rubbing a hard ink rubber over the surface to give the correct uneven texture.

Rosalind Buckland – Untitled illustration of beanshoots – 13½ x 17½in (33.75 x 43.75cm) – Watercolour

An airbrush can be used to create any number of startling images, such as this close-up illustration of beanshoots which Rosalind Buckland produced for her portfolio. The beans were sprayed with an overall tone and then small areas of the paint were rubbed off with a hard ink rubber to create the exact texture of beans. The highlights were scraped with a scalpel blade.

Ian Naylor

Untitled illustration of a watch mechanism – 16¾ x 23½ (42 x 59.5cm) – Watercolour, ink and gouache

The delicacy of touch required by some illustrations means that the artist has to use a combination of several media. In this illustration, commissioned for a book, Ian Naylor used gouache and watercolour to give body to the large components of the watch. The pieces of the mechanism made of polished steel were worked in ink, to give the appropriate bright finish.

Grose Thurston

Untitled illustration of a
mechanical digger

32 x 33in (80 x 82.5cm)

Gouache

Very often the size of an
original illustration seems to
bear no relation to the size at
which it is going to be
reproduced. This is because
working to a larger scale
means it is easier for the artist
to execute intricate work, and
also because the illustration

has more definition when it
is reduced to the correct size
for publication. This is
especially true in technical
illustrations, such as the one
shown here, where detail is
all-important. It was
commissioned by Case
Tractors, and therefore had to
be as technically accurate as
possible. After the completed
drawing was transferred to
CS10 line board, the artist
sprayed with gouache, using
low-tack adhesive film for the
hard masking. The
illustration was finished with
a fine sable paintbrush.

Grose Thurston

Untitled illustration of a
Tornado aircraft

16 x 14in (40 x 35cm)

Gouache

Artists are not always
commissioned to work on the
early stages of an illustration.
Here, the artist worked from
an existing line drawing, and
built up the form of the
aircraft with hard masking,
before applying the final
details to the illustration with
a fine sable paintbrush.

Grose Thurston

Untitled illustration of
Saturn

20 x 15in (50 x 37.5cm)

Gouache

The airbrush is ideal for
working on an illustration
such as this, which requires a
variety of techniques if it is to
succeed. Here, the stars were
created by holding the
airbrush close to the line
board and spraying in short,
sharp bursts.

Index

Page numbers in *italic* refer to captions and illustrations

Artists

The author and publishers wish to thank the following artists for their co-operation during the production of this book. The figures in italics show the pages on which their work is featured.

Melvyn Bagshaw
49 Lyndhurst Drive
London E10
See pages 98, 122, 125

Jim Bamber
24 Repton Way
Croxley Green
Rickmansworth
Hertfordshire
See page 110 (top)

Pete Brannon
22 Great Pulteney Street
London W1
See pages 95, 102-3, 116

Rosalind Buckland
c/o Ian Fleming and Associates Ltd
1 Wedgewood Mews
12-13 Greek Street
London
W1V 5PA
See pages 146-7, 148

Richard Duckett
24 Worple Road
London
SW19 4DD
See page 138

Nick Farmer
c/o Domino Studios
6 Haunch of Venison Yard
London
W1Y 1AF
See pages 124, 126

Grose Thurston
84a High Street
Braintree
Essex
See pages 111, 127, 150-1, 152-3, 154-5

Industrial Art Studio
Consols
St Ives
Cornwall
TR26 2HW
See pages 110 (bottom), 118-9, 120-1

Tom Liddell
52 Commonside
Ansdell
Lytham St Annes
Lancashire
See pages 106-7, 108-9

Ian Naylor
90 Milnthorpe Road
Kendal
Cumbria
LA9 5HE
See pages 114-5, 149

Keith Noble
Trevithian Farmhouse
Lanarth
St Keverne
Helston
Cornwall
See page 117

Roger Pearse
Aston Works
Back Lane
Aston
Oxfordshire
OX8 2DQ
See pages 94, 123, 140, 144-5

Tom Stimpson
40 Caversham Avenue
London
N13 4LN
See pages 96-7, 99, 100-1, 112-3, 128-9, 130, 131, 132-3, 135, 136-7, 142-3

Street Machine
AGB Specialist Publications Ltd
Audit House
Field End Road
Eastcote
Ruislip
Middlesex
HA4 9LT
See pages 104-5

Dick Ward
Aircraft Ltd
39-41 New Oxford Street
London WC1
See pages 92-3, 134, 139

Acknowledgements

The author and publishers wish to thank the following people and
organizations for their help in the preparation of this book:

Paul Rees, Flashpoint Studios, 8 Fitzroy Road, London NW1 8TX,
on whose photograph the artwork on p. 135 is based; Case Tractors;
Creative Photography Magazine; Simonson Finnegan; Street Machine
Magazine; and, in particular:

The De Vilbliss Company Limited
Ringwood Road
Bournemouth

Morris & Ingram (London) Ltd
156 Stanley Green Road
Poole
Dorset

Royal Sovereign Graphics
Brittania House
100 Drayton Park
London N5 1NA